That Still Moment

David Zwirner Books

ekphrasis

That Still Moment
Poetry and Essays on Dance
Edwin Denby

Selected and introduced by Cal Revely-Calder

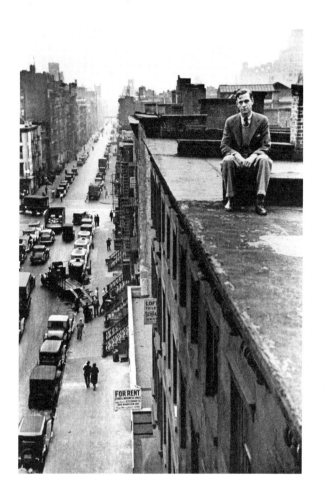

Rudy Burckhardt, *Edwin Denby on 21st Street*, c. 1937. Gelatin silver print

Contents

Interesting Opinions

Cal Revely-Calder

Edwin Denby lived in hope. When it comes to classical ballet, he writes, "What correct style exists for, what it hopes for, is a singular, unforeseen, an out-of-this-world beauty of expression."[1] You might catch it in the shape of a dancer's pose, or in the way she lands a leap. A single movement can hold such grace. And it need not last; in fact, it never could. What makes choreography "beautiful," says Denby—thinking of George Balanchine—is seeing "the unique liveliness of each dancer caught entirely in the present instant that at once, we all know it, will be past and irretrievable forever."[2]

Denby, who lived from 1903 to 1983, is best known for his writings on dance, in particular ballet. After training as a modern dancer himself, he became the dance critic of the *New York Herald Tribune* in 1942, moving on in 1945, when the younger house critic, Walter Terry, returned from the war. The paper had three hundred thousand weekday readers; on Sundays, double that. Dance critics were then, as now, at a premium, and Denby had an audience that few peers, as now, could expect. It didn't go to his head. "I guess a critic," he writes, "won't quite avoid being a bit of a pedagogue and a bit of a charlatan."[3] He summarizes his task as "to notice, to order, to report; ... to put down a sort of portrait of what went on."[4] What was going on was rather a lot, with the ballet being revamped by Balanchine and modern dance by the likes of Merce Cunningham. Denby witnessed and judged it all. His colleague Arlene Croce has described his collection *Looking at the Dance* (1949) as "the most

universally admired book of dance criticism in American publishing history."[5] Clive Barnes, another peer, has called Denby "the good grey father of dance criticism," a Walt Whitman of the stage.[6]

Born in China, where his diplomat father was posted, Denby lived in Vienna before the family returned, in 1915, to the United States. He went to Harvard in 1921 but left for New York the following year, with the aim of becoming a poet. That didn't yet work out—he would find his voice two decades on—so he headed to Germany in 1923, where he trained in *Grotesktanz*, a modern and satirical style of dance. He traveled across Europe and to the USSR, forming a partnership with the like-minded dancer Claire Eckstein. In his first essay, "Arts and Crafts in Dancing," he writes: "In Germany, as in all other countries alive to the dance, a controversy exists between two schools of techniques—the ballet and the new dance, or space-dance."[7] Alongside the piece was a photograph of performers from the Hellerau School, where Denby studied; they're caught in jazzy stances and wear comical masks with giant eyes.

In 1935, fleeing a land under Nazi rule, he returned to America. He arrived two years after Balanchine. As Margaret Fuhrer writes, at the time "American dance consisted of the decadent glitz of Broadway and the Puritan austerity of Martha Graham—and little else."[8] Balanchine, who had danced in the Ballets Russes, would soon transform the art, creating an idiom that is sleek and unflamboyant while respecting dance

tradition: a new American ballet. His style is often called neoclassical; Denby says it is "grand without being impressive, clear without being strict[,] ... humane because it is based on the patterns the human body makes."[9]

Denby became Balanchine's champion. In particular, Denby adored his "musicality," how—unfashionably among choreographers—Balanchine put a "time corset" on his dancers.[10] Their movements are tied to musical structure, so that beauty flows not from expressive liberty but from its relation to formal dictates: as in any true *tempo rubato*, the accompaniment keeps melody on a leash. Balanchine described himself as a "ballet carpenter," "a cabinetmaker [who] must select his woods for the particular job at hand."[11] Compare how Denby later spoke about writing a sonnet: "The form itself is such a handy challenge.... It's like making a small table or chair."[12]

As a critic, Denby doesn't theorize; he describes. He doesn't want dancing, or any art, to validate a belief, and he hasn't much love for plot. You go to a dance show, he thinks, to see dancing, not to find out whether Albrecht and Giselle will elope. When he saw Doris Humphrey's *Inquest* (1948), in which poverty crushes a family, he refused to be impressed: "*Inquest* is concerned with reminding us of an idea we all approve and urging us to act on it."[13] In 1956, during a panel discussion titled "Problems of the Engaged Artist," with John Cage and Barnett Newman at the Eighth Street Club in New York,

he disdained the idea that political engagement might be the purpose of making art. Form is not didactic, nor should its incarnation be. In 1939, not long after returning from Germany, he wrote that modern-dance groups make him "uncomfortable," because "the dancers seem to disappear as human beings and only function as instruments.... They seem artificially depersonalized, and their bodies operated from offstage."[14] He looks instead for signs of life, arranged formally then articulated in attractive, measured ways: his criticism resounds with words such as "elegance," "harmony," and "aplomb." As he put it, slyly, in 1951: "I don't approve of dancers who don't dance like dancers."[15]

All the same, you can dance without being onstage, and without even being a dancer. In a 1960 review of the Bolshoi performing in New York, Denby praises Galina Ulanova's sprints and adds, "You can find out something about Bolshoi style by trying the gymnastics of Ulanova's fling and rush."[16] He gives step-by-step instructions to the readers of the *Hudson Review* to replicate the routine at home. "If your family is watching, they will pick you off the floor, and urge you to try harder."[17] It sounds as if he were teasing, but he is serious. While at Harvard, he slipped from his seat at the Boston Symphony Orchestra to dance to Wagner in the corridor; as an adult, he would try out steps in his apartment or on the city streets. While studying photographs of Vaslav Nijinsky, he tasked the photographer Rudy Burckhardt and the painter Elaine de Kooning with holding the

poses the great dancer made. As the poet Bill Berkson observes, "He seemed fascinated by whatever transformation any type of movement might make for oneself."[18] Denby is a practical critic: his forms of motion are forms of thought.

*

* *

Denby's early poems, including several sonnets from the 1920s and an autobiographical epic in three books (though he had planned for four), are mostly lost. Instead, his career begins with *In Public, In Private*, published in 1948. These poems, strange and elegant, are citizens of Manhattan; they love the "smudgy film of smoke" in the avenues as much as the "luminously livid" clouds above.[19] In "City without Smoke," after a gale "the exposed city looks like deserted dunes," while amid the heat wave of "People on Sunday," "the long asphalt looks dead like a beach." Men play ball on corners; girls strut down the avenues. The city thrives in the present tense, as in the poem "21," from "A Sonnet Sequence":

So a million people are a public secret
(As night is a quieter portion of the day)
These are their private lives tearing down the street
Stepping past mouldings and past 'Special Today.'

Sometimes the syntax is tangled, as if impressions were clashing: "Time in every sky I look at next to people / Is more private than thought is, or upstairs sleeping."[20] Elsewhere, the poems swing along on contractions, anaphora, and monosyllables—the easy material of casual talk.

When he settled in Manhattan in 1935, Denby rented an apartment with Burckhardt, then his lover, at 145 West Twenty-First Street. (Denby would live there until his death.) Soon after moving in, they met Willem de Kooning, from number 143, when a rainstorm blew in and de Kooning's cat washed up on their fire escape. The trio became close friends and would walk the streets together at night, training their eyes on the urban scene. Denby gave the poem "The Silence at Night" the epigraph "The designs on the sidewalk Bill pointed out," after which the first lines go: "The sidewalk cracks, gumspots, the water, the bits of refuse, / They reach out and bloom under arclight, neonlight." In an essay ten years later, these walks and their visual miracles were still lingering in his mind. De Kooning, he says, "pointed to instances—a gesture, a crack, some refuse, a glow—where for a moment nature did it, the mysteriousness you recognize in a masterpiece."[21]

Denby lived for the flow of the city, its perpetual ballet. He saw its citizens as bodies in motion, their steps on the sidewalk analogous to those he saw on the stage. He was a model of observation. In the sonnet "Standing on the Streetcorner," he describes how New Yorkers "dominate

the pavement from where they stand," even if "middle-age distends them like a vast dream / While boys and girls pass glancing to either hand." If there's a gap between how we move in the street and on the stage, it's one of function, not of form. (For that reason, in this volume Denby's dance essays and poems are intertwined: each form speaks to the other's sense of rhythm, balance, and physical prowess.) The historian Joe Moran has written that, confronted by an elaborate architecture of metal and stone and glass, and the many bodies of one another, city dwellers move with "nonchalant virtuosity."[22] We tap our credit cards to enter the subway; we hustle en masse but rarely collide. In "Dancers, Buildings, and People in the Streets," a lecture intended (but never given) for students at Juilliard, Denby talks about "dancing in daily life," in nightclubs and everywhere else. He tells us, eyes alight: "Daily life is wonderfully full of things to see. Not only people's movements, but the objects around them, the shape of the rooms they live in, the ornaments architects make around windows and doors, the peculiar ways buildings end in the air, the water tanks, the fantastic differences in their street facades on the first floor."

Frank O'Hara, also a poet and critic, introduces Denby's second collection of essays, *Dancers, Buildings, and People in the Streets* (1965), by saying, "He sees and hears more clearly than anyone else I have ever known."[23] O'Hara framed Denby well in his poem "A Step Away from Them":

> Everything
> suddenly honks: it is 12:40 of
> a Thursday.
> Neon in daylight is a
> great pleasure, as Edwin Denby would
> write, as are light bulbs in daylight.[24]

This catches the repetition of "daylight," a fussiness native to Denby's style, and the word "pleasure," which appears in many of his pieces on dance. Denby, in turn, said in a 1983 interview that he loved O'Hara's curiosity: "He never asked any questions like someone trying to find out who you were. He just took it all in."[25] These reciprocities gesture nicely to Denby's love of companionship, of being and seeing with friends. He dined most days with them, and went with them to dance performances a couple of times a week. The poet Alice Notley has recalled how they would usually travel by subway, as Denby loved that "it was the last place where you were allowed to stare at people."[26] Then, at the end of the evening, when the show was over, the group would head back to his loft. "We'd drink bourbon," Joe LeSueur, another poet, remembers, "nibble on whatever tidbits Edwin could rustle up, reflect on the ballets we'd seen ... and then go on to related aesthetic matters."[27] Or, as O'Hara frames it in his poem "Dances Before the Wall": "we go to Edwin Denby's and quietly talk all night."[28]

In its devotion to the streets, its crisp and languid voice, *In Public, In Private* has a strong claim to be the

first book of New York School poetry (O'Hara's *Lunch Poems* and John Ashbery's *Tennis Court Oath* were still more than a decade away). As the new generation— including Ashbery and O'Hara, James Schuyler and Kenneth Koch, critics such as Barnes and painters such as Alex Katz—blossomed in Manhattan, Denby, more than twenty years older, became variously mentor or friend. He won a Guggenheim Fellowship in 1948, enabling a trip that gave us *Mediterranean Cities* (1956), a passionate poetic sequence set in Greece and Italy. His final years produced another superb collection, *Snoring in New York* (1974), and a growing, albeit local, readership. But he'd stopped writing new poems in the late 1960s, and he only revised existing ones over the next two decades, until his suicide, at eighty years old.

Denby was overlooked before he'd even ceased writing. He wasn't included in the New York section of *The New American Poetry*, the major 1960 anthology in which Donald Allen mapped out who was who. O'Hara's stature was cemented by his death in 1966, Ashbery's by his Pulitzer Prize in 1976; yet, three years after Denby's passing, Ashbery marveled that his friend was still "American poetry's best-kept secret."[29] Denby had never sought to be widely printed, nor could he bear effusive praise. When his *Collected Poems* appeared in 1975, it was thanks to Ron Padgett and two coeditors, who told him the book was happening whether he wanted it or not.

*

* *

Denby was known to carry a copy of *Inferno* as he walked about New York. Among the things he valued in Dante was the way he "creates an image in only a few clear sharp lines and then changes the subject before you lose the image. The ability to do that in dance is just as extraordinary as achieving the same effect in poetry—to change the whole look of the stage . . . without making the viewer painfully aware of what is happening. Balanchine does this constantly, and seeing his skill at work is a source of considerable pleasure."[30] If there's such a thing as a "Denby moment," it's the aftermath: the brief life of an image before another supplants it in our sight.

One word for this transient beauty is "grace." It is a word that hovers about Denby's person. After his death, his friends and admirers spoke of his otherworldly aspect, a benevolence of character and disposition toward the world. He wanted to be repeatedly pleased; for forms to cohere in beauty, then diverge and cohere again. Padgett called him "a radiant gentleman," a description that reminds me of Aquinas's line that grace is "the life of the soul," and "radiance of soul is a quality, just like beauty of body."[31] For Denby, writes the scholar Gay Morris, "classicism embodied the civilizing virtues of grace, courtesy and harmony."[32] What Denby shared with de Kooning and O'Hara was a desire to experience the cusp, those moments of anticipation before great

pleasure is had. The source might be danced, or painted, or photographed, or merely seen across the square, but it is a coherence of visual circumstance, a gift of graceful form.

Denby usually ends his sonnets with perfect rhymes, except in his final, unhappiest poems, in which night walks happen solo and rhythms grow juddering and cracked. Everywhere else, satisfaction is kept in view, as in two poems that conclude with grace itself: "City without Smoke" and "Five Reflections." In the final couplets, Denby finds "grace" in mortality as a "face" appears and beholds the scene, and between the words, you hear the briefest intimacy as two sounds join, then fade away. It is the sort of performance of pleasure that Denby loved to chase. What is special about him is the way he noticed what others thought too basic to see. Balanchine's dancers, he explains, "have an indefinable grace in dancing that seems to come naturally to them, that seems extemporaneous. They look not so much like professionals but like boys and girls who are dancing."[33] Or like people in the street.

Notes

1 Edwin Denby, "Some Thoughts about Classicism and Georges Balanchine," *Dance Magazine* (February 1953). Reprinted in *Dance Writings and Poetry*, ed. Robert Cornfield (London: Yale University Press, 1998), p. 242.

2 Denby, "Balanchine and Tchaikovsky: *Ballet Imperial*," *Modern Music* (January–February 1943). Reprinted in *Dance Writings and Poetry*, p. 69.

3 Denby, "A Forum on Dance Criticism," *New York Herald Tribune*, April 2, 1944. Reprinted in *Dance Writings and Poetry*, p. 116.

4 Denby, "A Forum on Dance Criticism," p. 117.

5 Arlene Croce quoted in Nick Sturm, "Feelings Are Our Facts," Poetry Foundation, poetryfoundation.org/articles/158659/feelings-are-our-facts.

6 Clive Barnes, collected in *Dance and Dancers* 478–489 (London: Hansom, 1990).

7 Denby, "Art and Craft in Dancing: Conflicting Tendencies and Schools in Contemporary Europe," *Theatre Guild Magazine* (January 1929), p. 35.

8 Margaret Fuhrer, "Denby and Balanchine: A Dance Critic's Work," *Brooklyn Rail* (July–August 2008).

9 Denby, "*Serenade*," *New York Herald Tribune*, April 15, 1944. Reprinted in *Dance Writings and Poetry*, p. 118.

10 Denby, "*Serenade*," p. 118; George Balanchine quoted in Stephanie Jordan, "Music Puts a Time Corset on the Dance," *Dance Chronicle* 16 (January 1993), p. 295.

11 George Balanchine and Francis Mason, *101 Stories of the Great Ballets* (New York: Alfred A. Knopf, 1975), p. 3.

12 Denby quoted in Mark Hillringhouse, "An Interview with Edwin Denby," *Mag City* 14 (1983), p. 104.

13 Denby, "Humphrey's *Inquest*," *New York Herald Tribune*, March 12, 1944. Reprinted in *Dance Writings and Poetry*, p. 114.

14 Denby, "Looking Human," in Denby, *Looking at the Dance* (New York: Pellegrini & Cudahy, 1949), p. 299.

15 Denby, "A Letter About Ulanova," *Ballet* (August 1951). Reprinted in *Dance Writings and Poetry*, p. 211.

16 Denby, "The Bolshoi at the Met," *Hudson Review* (Winter 1959–1960). Reprinted in *Dance Writings and Poetry*, p. 276.

17 Denby, "The Bolshoi at the Met," p. 276.

18 Bill Berkson quoted in Sturm, "Feelings Are Our Facts."

19 Denby, "City without Smoke," this volume, p. 60.

20 Denby, "Standing on the Streetcorner," this volume, p. 59.

21 Denby, *Willem de Kooning* (New York: Hanuman, 1988), p. 26.

22 Joe Moran, *Reading the Everyday* (London: Routledge, 2005), p. 52.

23 Frank O'Hara, introduction to Denby, *Dancers, Buildings, and People in the Streets* (New York: Horizon, 1965), p. 9.

24 Frank O'Hara, *Lunch Poems* (San Francisco: City Lights, 1964), p. 16.

25 Denby quoted in Hillringhouse, "An Interview with Edwin Denby," p. 112.

26 Alice Notley, "Intersections with Edwin's Lines," *Jacket* 21 (February 2003), accessed online.

27 Joe LeSueur, *Digressions on Some Poems by Frank O'Hara* (New York: Farrar, Straus and Giroux, 2003), p. 93.

28 Gillian Jakab first noticed this reference. See "The Fact That You Move So Beautifully," *Gagosian Quarterly* (Summer 2020); Frank O'Hara, "Dances Before the Wall," *The Collected Poems of Frank O'Hara*, ed. Donald Allen (New York: Alfred A. Knopf, 1971), p. 345.

29 John Ashbery quoted in Mary Maxwell, "Edwin Denby's New York School," *Yale Review* 95 (2007), p. 95.

30 Denby quoted in Fuhrer, "Denby and Balanchine: A Dance Critic's Work."

31 Ron Padgett quoted in Maxwell, "Edwin Denby's New York School," p. 94.

32 Gay Morris, *A Game for Dancers: Performing Modernism in the Postwar Years, 1945–1960* (Middletown, CT: Wesleyan University Press, 2006), p. 83.

33 Denby, "Balanchine and Tchaikovsky: *Ballet Imperial*," p. 69.

That Still Moment

Edwin Denby

Dancers, Buildings, and People in the Streets

On the subject of dance criticism, I should like to make clear a distinction that I believe is very valuable, to keep the question from getting confused. And that is that there are two quite different aspects to it. One part of dance criticism is seeing what is happening onstage. The other is describing clearly what it is you saw. Seeing something happen is always fun for everybody, until they get exhausted. It is very exhausting to keep looking, of course, just as it is to keep doing anything else; and from an instinct of self-preservation many people look only a little. One can get along in life perfectly well without looking much. You all know how very little one is likely to see happening on the street—a familiar street at a familiar time of day while one is using the street to get somewhere. So much is happening inside one, one's private excitements and responsibilities, one can't find the energy to watch the strangers passing by, or the architecture, or the weather around; one feels there is a use in getting to the place one is headed for and doing something or other there, getting a book or succeeding in a job or discussing a situation with a friend, all that has a use, but what use is there in looking at the momentary look of the street, of 106th and Broadway. No use at all. Looking at a dance performance has some use, presumably. And certainly it is a great deal less exhausting than looking at the disjointed fragments of impression that one can see in traffic. Not only that the performance is

arranged so that it is convenient to look at, easy to pay continuous attention to, and attractive, but also that the excitement in it seems to have points of contact with the excitement of one's own personal life, with the curiosity that makes one want to go get a special book, or the exciting self-importance that makes one want to succeed, or even the absorbing drama of talking and listening to someone of one's own age with whom one is on the verge of being in love. When you feel that the emotion that is coming toward you from the performance is like a part of your own at some moment when you were very excited, it is easy to be interested. And of course if you feel the audience thrilled all around you just when you are thrilled, too, that is very peculiar and agreeable. Instead of those people and houses on the street that are only vaguely related to you in the sense that they are Americans and contemporary, here in the theater you are almost like in some imaginary family, where everybody is talking about something that concerns you intimately and everybody is interested and to a certain extent understands your own viewpoint and the irrational convictions you have that are even more urgent than your viewpoint. The amplitude that you feel you see with at your most intelligent moments, this amplitude seems in the theater to be naturally understood onstage and in the audience, in a way it isn't often appreciated while you are with the people you know outside the theater. At a show you can tell perfectly well when it is happening to you, this experience of an enlarged view of what is really so and true, or when

it isn't happening to you. When you talk to your friends about it after the curtain goes down, they sometimes agree, and sometimes they don't. And it is strange how whether they do or don't, it is very hard usually to specify what the excitement was about, or the precise point at which it gave you the feeling of being really beautiful. Brilliant, magnificent, stupendous, no doubt all these things are true of the performance, but even if you and your friends agree that it was all those things, it is likely that there was some particular moment that made a special impression which you are not talking about. Maybe you are afraid that that particular moment wasn't really the most important, that it didn't express the idea or that it didn't get special applause or wasn't the climax. You were really excited by the performance and now you are afraid you can't show you understand it. Meanwhile, while you hesitate to talk about it, a friend in the crowd who talks more readily is delivering a brilliant criticism specifying technical dance details, moral implications, musicological or iconographic finesses; or else maybe he is sailing off into a wild nonsensical camp that has nothing to do with the piece but which is fun to listen to, even though it's a familiar trick of his. So the evening slips out of your awareness like many others. Did you really see anything? Did you see any more than you saw in the morning on the street? Was it a real excitement you felt? What is left over of the wonderful moment you had, or didn't you really have any wonderful moment at all, where you actually saw onstage a real person moving

and you felt the relation to your real private life with a sudden poignancy as if for that second you were drunk? Dance criticism has two different aspects: one is being made drunk for a second by seeing something happen; the other is expressing lucidly what you saw when you were drunk. I suppose I should add quite stuffily that it is the performance you should get drunk on, not anything else. But I am sure you have understood me anyway.

Now the second part of the criticism, that of expressing lucidly what happened, is of course what makes criticism criticism. If you are going in for criticism you must have the gift in the first place, and in the second place you must cultivate it, you must practice and try. Writing criticism is a subject of interest to those who do it, but it is a separate process from that of seeing what happens. And seeing what happens is of course of much more general interest. This is what you presumably have a gift for, since you have chosen dancing as a subject of special study, and no doubt you have already cultivated this gift. I am sure you would, all of you, have something interesting and personal to say about what one can see and perhaps, too, about what one can't see.

Seeing is at any rate the subject I would like to talk about today. I can well imagine that for some of you this is not a subject of prime interest. Some of you are much more occupied with creating or inventing dances than with seeing them; when you look at them you look at them from the point of view of an artist who is concerned with his own, with her own, creating. Creating, of course,

is very exciting, and it is very exciting whether you are good at it or not; you must have noticed that already in watching other people create, whose work looks silly to you, but whose excitement, even if you think it ought not to be, is just as serious to them as that of a creator whose creating isn't silly. But creating dancing and seeing dancing are not the same excitement. And it is not about creating that I mean to speak; I am telling you this so you won't sit here unless you can spare the time for considering in a disinterested way what seeing is like; please don't feel embarrassed about leaving now, though I agree it would be rude of you to leave later. And it is not very likely either that I shall tell you any facts that you had better write down. I rather think you know all the same facts I do about dancing, and certainly you know some I don't; I have forgotten some I used to know. About facts, too, what interests me now is how different they can look, one sees them one way and one sees them another way another time, and yet one is still seeing the same fact. Facts have a way of dancing about, now performing a solo, then reappearing in the chorus, linking themselves now with facts of one kind, now with facts of another, and quite changing their style as they do. Of course you have to know the facts so you can recognize them, or you can't appreciate how they move, how they keep dancing. We are supposed to discuss dance history sometime in this seminar and I hope we will. But not today.

At the beginning of what I said today I talked about one sort of seeing, namely a kind that leads to recognizing

onstage and inside yourself an echo of some personal, original excitement you already know. I call it an echo because I am supposing that the event which originally caused the excitement in oneself is not literally the same as the event you see happen onstage. I myself, for instance, have never been a prince or fallen in love with a creature that was half girl and half swan, nor have I myself been an enchanted swan princess, but I have been really moved and transported by some performances of *Swan Lake*, and by both sides of that story. In fact, it is much more exciting if I can feel both sides happening to me, and not just one. But I am sure you have already jumped ahead of me to the next step of the argument, and you can see not only that I have never been such people or been in their situation, but besides that I don't look like either of them; nor could I, even if I were inspired, dance the steps the way they do. Nor even the steps of the other dancers, the soloists, or the chorus.

You don't seem to have taken these remarks of mine as a joke. But I hope you realized that I was pointing out that the kind of identification one feels at a dance performance with the performers is not a literal kind. On the other hand, it is very probable that you yourselves watch a dance performance with a certain professional awareness of what is going on.

A professional sees quite clearly "I could do that better, I couldn't do that nearly so well." A professional sees the finesse or the awkwardness of a performer very distinctly, at least in a field of dance execution he or she is

accustomed to working in; and a choreographer sees similarly how a piece is put together, or, as the phrase is, how the material has been handled. But this is evidently a very special way of looking at a performance. One may go further and say that a theater performance is not intended to be seen from this special viewpoint. Craftsmanship is a matter of professional ethics; a surgeon is not bound to explain to you what he is doing while he is operating on you, and similarly no art form, no theater form is meant to succeed in creating its magic with the professionals scattered in the audience. Other doctors seeing a cure may say, "Your doctor was a quack but he was lucky"; and similarly, professionals may say after a performance, "Yes, the ballerina was stupendous, she didn't fake a thing"—or else say, "She may not have thrilled you, but there aren't four girls in the world who can do a something or other the way she did"—and this is all to the good, it is honorable and it is real seeing. But I am interested just now to bring to your attention or recall to your experience not that professional way of seeing, but a more general way. I am interested at the moment in recalling to you how it looks when one sees dancing as nonprofessionals do, in the way you yourselves I suppose look at pictures, at buildings, at political history or at landscapes or at strangers you pass on the street. Or as you read poetry.

In other words, the way you look at daily life or at art for the mere pleasure of seeing, without trying to put yourself actively in it, without meaning to do

anything about it. I am talking about seeing what happens when people are dancing, seeing how they look. Watching them and appreciating the beauty they show. Appreciating the ugliness they show if that's what you see. Saying this is beautiful, this is ugly, this is nothing as far as I can see. As long as you pay attention there is always something going on, either attractive or unattractive, but nobody can always pay attention, so sometimes there is nothing as far as you can see, because you have really had enough of seeing; and quite often there is very little, but anyway you are looking at people dancing, and you are seeing them while they dance.

Speaking personally, I think there is quite a difference between seeing people dance as part of daily life and seeing them dance in a theater performance. Seeing them dance as part of daily life is seeing people dance in a living room or a ballroom or a nightclub, or seeing them dance folk dances either naturally or artificially in a folk dance group. For that matter classroom dancing and even rehearsal dancing seem to me a part of daily life, though they are as special as seeing a surgeon operate or hearing the boss blow up in his office. Dancing in daily life is also seeing the pretty movements and gestures people make. In the Caribbean, for instance, the walk is often, well, miraculous—both the feminine stroll and the masculine one, each entirely different. In Italy you see another beautiful way of strolling, that of shorter muscles, more complex in their plasticity, with girls deliciously turning their breast very slightly, deli-

ciously pointing their feet. You should see how harmoniously the young men can loll. American young men loll quite differently, resting on a peripheral point; Italians loll resting on a more central one. Italians on the street, boys and girls, both have an extraordinary sense of the space they really occupy, and of filling that space harmoniously as they rest or move. Americans occupy a much larger space than their actual bodies do; I mean, to follow the harmony of their movement or of their lolling you have to include a much larger area in space than they are actually occupying. This annoys many Europeans; it annoys their instinct of modesty. But it has a beauty of its own, which a few of them appreciate. It has, so to speak, an intellectual appeal; it has because it refers to an imaginary space, an imaginary volume, not to a real and visible one. Europeans sense the intellectual volume but they fail to see how it is filled by intellectual concepts—so they suppose that the American they see lolling and assuming to himself too much space, more space than he actually needs, is a kind of a conqueror, is a kind of nonintellectual or merely material occupying power. In Italy I have watched American sailors, soldiers, and tourists, all with the same expansive instinct in their movements and their repose, looking like people from another planet among Italians, with their self-contained and traditionally centered movements. To me these Americans looked quite uncomfortable, and embarrassed, quite willing to look smaller if they only knew how. Here in New York, where everybody expects

them to look the way they do, Americans look unselfconscious and modest despite their traditional expansivity of movement. There is room enough. Not because there is actually more—there isn't in New York—but because people expect it, they like it if people move that way. Europeans who arrive here look peculiarly circumspect and tight to us. Foreign sailors in Times Square look completely swamped in the big imaginary masses surging around and over them.

Well, this is what I mean by dancing in daily life. For myself I think the walk of New Yorkers is amazingly beautiful, so large and clear. But when I go inland, or out West, it is much sweeter. On the other hand, it has very little either of Caribbean lusciousness or of Italian contrapposto. It hasn't much to savor, to roll on your tongue; that it hasn't. Or at least you have to be quite subtle, or very much in love, to distinguish so delicate a perfume.

That, of course, is supposed to be another joke, but naturally you would rather travel yourself than hear about it. I can't expect you to see my point without having been to countries where the way of walking is quite different from what ours is here. However, if you were observant, and you ought to be as dance majors, you would have enjoyed the many kinds of walking you can see right in this city, boys and girls, Negro and white, Puerto Rican and Western American and Eastern, foreigners, professors, and dancers, mechanics and businessmen, ladies entering a theater with half a drink too much, and shoppers at Macy's. You can see everything in the world here

in isolated examples at least, peculiar characters or people who are, for the moment you see them, peculiar. And everybody is quite peculiar now and then. Not to mention how peculiar anybody can be at home.

Daily life is wonderfully full of things to see. Not only people's movements, but the objects around them, the shape of the rooms they live in, the ornaments architects make around windows and doors, the peculiar ways buildings end in the air, the water tanks, the fantastic differences in their street facades on the first floor. A French composer who was here said to me, "I had expected the streets of New York to be monotonous, after looking at a map of all those rectangles; but now that I see the differences in height between buildings, I find I have never seen streets so diverse one from another." But if you start looking at New York architecture, you will notice not only the sometimes extraordinary delicacy of the window framings, but also the standpipes, the grandiose plaques of granite and marble on ground floors of office buildings, the windowless side walls, the careful, though senseless, marble ornaments. And then the masses, the way the office and factory buildings pile up together in perspective. And under them the drive of traffic, those brilliantly colored trucks with their fanciful lettering, the violent paint on cars, signs, houses as well as lips. Sunsets turn the red-painted houses in the cross streets to the flush of live rose petals. And the summer sky of New York for that matter is as magnificent as the sky of Venice. Do you see all this? Do you

see what a forty- or sixty-story building looks like from straight below? And do you see how it comes up from the sidewalk as if it intended to go up no more than five stories? Do you see the bluish haze on the city as if you were in a forest? As for myself, I wouldn't have seen such things if I hadn't seen them first in the photographs of Rudolph Burckhardt. But after seeing them in his photographs, I went out to look if it were true. And it was. There is no excuse for you as dance majors not to discover them for yourselves. Go and see them. There is no point in living here if you don't see the city you are living in. And after you have seen Manhattan, you can discover other grandeurs out in Queens, in Brooklyn, and in those stinking marshes of Jersey.

All that is here. And it is worth seeing. When you get to Rome, or to Fez in Morocco, or to Paris, or to Constantinople, or to Peking—I hope you will get there; I have always wanted to—you will see other things beautiful in another way. But meanwhile, since you are dance majors and are interested and gifted in seeing, look around here. If you cut my talks and bring me instead a report of what you saw in the city, I will certainly mark you present, and if you can report something interesting I will give you a good mark. It is absurd to sit here in four walls while all that extraordinary interest is going on around us. But then education is a lazy, a dull way of learning, and you seem to have chosen it; forget it.

However, if you will insist on listening to me instead of going out and looking for yourselves, I will have to

go on with this nonsense. Since you are here, I have to go on talking and you listening, instead of you and me walking around and seeing things. And I have to go on logically, which we both realize is nonsense. Logically having talked about what you can see in daily life, I have to go on to that very different way of seeing, which you use in seeing art.

For myself, I make a distinction between seeing daily life and seeing art. Not that seeing is different. Seeing is the same. But seeing art is seeing an ordered and imaginary world, subjective and concentrated. Seeing in the theater is seeing what you don't see quite that way in life. In fact, it's nothing like that way. You sit all evening in one place and look at an illuminated stage, and music is going on, and people are performing who have been trained in some peculiar way for years, and since we are talking about a dance performance, nobody is expected to say a word, either onstage or in the house. It is all very peculiar. But there are quite a lot of people, ordinary enough citizens, watching the stage along with you. All these people in the audience are used to having information conveyed to them by words spoken or written, but here they are just looking at young people dancing to music. And they expect to have something interesting conveyed to them. It is certainly peculiar.

But then, art is peculiar. I won't speak of concert music, which is obviously peculiar, and which thousands every evening listen to, and evidently get satisfaction out of. But even painting is a strange thing. That people will

look at some dirt on a canvas, just a little rectangle on a wall, and get all sorts of exalted feelings and ideas from it is not at all natural, it is not at all obvious. Why do they prefer one picture so much to another one? They will tell you and get very eloquent, but it does seem unreasonable. It seems unreasonable if you don't see it. And for all the other arts it's the same. The difference between the "Ode on a Grecian Urn" and a letter on the editorial page of the *Daily News* isn't so great if you look at both of them without reading them. Art is certainly even more mysterious and nonsensical than daily life. But what a pleasure it can be. A pleasure much more extraordinary than a hydrogen bomb is extraordinary.

There is nothing everyday about art. There is nothing everyday about dancing as an art. And that is the extraordinary pleasure of seeing it. I think that is enough for today.

Center, December 1954

Dance Criticism

People interested in dancing as a form of art complain that our dance criticism is poor. Poor it is but not poor in relation to its pay. Anyone who writes intelligently about dancing does so at his own expense. As a matter of fact the sort of semi-illiterate hackwork that oozes out shamelessly and pays off modestly in books and articles about music—educators recommend it—is hardly profitable when it deals with the dance. Almost all our dance criticism appears in the form of newspaper reviewing. But almost all papers would rather misinform the public than keep a specialized dance reporter. Even rich ones delight in skimping on costs by sending out a staff music critic who covers ballet as an extra unpaid chore.

In the whole country only three exceptionally well-edited papers have made a practice of employing specialized dance critics—the *New York Times*, the *New York Herald Tribune*, and the *Christian Science Monitor*—and a fourth, the *Chicago Times*, joined them in 1947. These four jobs, the best that specialists can hope for, carry an average salary below that of a trombonist in the pit and hardly comparable to that of a minor, not very reliable soloist onstage. If the profit motive is a sacred American right, it is easier to account for miserable performances by our writers than for acceptable ones. Nevertheless, among the mass of nonsense printed each year about dancing, a few specialists and gifted amateurs do produce on their own initiative a trickle of vivid reporting,

of informed technical discussion, of valuable historical research and striking critical insight. The conditions and the average quality of dance criticism seem to be similar the world over. Ours is no worse than that elsewhere, except that there is more of it packaged for breakfast.

Most of our criticism is poor but many readers hardly mind how foolish it is; they read it too inattentively to notice. Some of them glance at a review only to see if the verdict on a show is for or against their going. Others, who have opinions of their own, are eager to quote what the paper said either with rage or with pride. In their eagerness they often misquote what they read and catch the meaning of written words as vaguely as a playful dog does that of speech. Anyone who writes for a paper is expected to satisfy the canine eagerness of many readers. They love to be bullied and wheedled; to be floored by a wisecrack, excited by gossip, inflamed by appeals to bigotry or popular prejudice; they love a female critic to gasp or fret and a male critic to be as opinionated as a comedian. At this level the difference between good and bad criticism is slight; and if you have to read foolish criticism this is as much fun as you can get out of it.

There are, however, many people, too, who like to find sense even in a dance column. They expect a critic writing as an educated American to give them a clear picture of the event and to place it in its relation to the art of theater dancing. When good criticism appears in a large newspaper many people welcome and appreciate it. Many all over the country know very well what ballet

is about and follow intelligent reviewing, not necessarily with agreement but with spontaneous interest. They realize that a good editor can give it to them and that one who doesn't is in this respect slovenly.

To judge a ballet performance as attentively as a work of imagination is judged and by similar standards is nowadays normal enough. To be sure, everyone doesn't respond to a high degree of imagination in dancing, and not every intelligent person is convinced that dancing can create the peculiar spell, intimate, sustained, and grand, a work of art does. But in the course of the last two centuries enough intelligent people have been convinced it can, so that now the possibility is normally accepted. Our stage dancing is less abundant an art than our music, painting, or literature; but its claim to serious attention is that it belongs like them to the formal world of civilized fantasy. In recent years ballet has been the liveliest form of poetic theater we have had.

Dancing that is pleasing and neat, that shows ingenuity and a touch of fancy, is no news in a luxurious city. But dancing that by its sequence of movements and rhythm creates an absorbing imaginative spell is a special attraction a journalist must be able to recognize and describe. The prestige position of a ballet company depends entirely on how well its performances maintain, for people who know what art or poetry is about, a spell as art and a power as poetry. It is these imaginative people who can watch with attention—there are many thousands of them in New York—whose satisfaction stimulates

general curiosity and influences wealthy art patrons to pay the deficits. They go for pleasure, just as they might go to a concert by Gold and Fizdale at Town Hall or else read Stendhal or Jane Bowles at home. Dancing delights them where they see it become an art and it is to see this happen that they like to go. What they want to find out from a review is, Did an event of artistic interest take place, and if it did, what particular flavor did it have? And because they are the readers really interested in what only a dance reporter can tell them, it is his business to answer their questions distinctly.

If his report interests them, they will go and see for themselves, and incidentally they will notice the sort of news they can rely on him for. If his remarks often turn out to be illuminating, he is judged a good critic; too many foolish or evasive reports on the other hand make him lose his status as a valuable observer. They expect him to recognize and formulate the point at issue in a performance more quickly and sharply than they would themselves. But without considerable experience in several arts, and of dancing and its technical basis, too, the observer has no standards by which to measure and no practice in disentangling the pretensions of a ballet from its achievements. That is why a newspaper that wants to inform its readers on interesting dance events has to keep a reporter with the particular gift and training needed for the job.

A dance journalist's business is to sketch a lively portrait of the event he is dealing with. His most interesting

task is to describe the nature of the dancing—what imaginative spell it aims for, what method it proceeds by, and what it achieves. In relation to the performance, he describes the gifts or the development of artists, the technical basis of aesthetic effects, even the organizational problems that affect artistic production. The more distinctly he expresses himself, the more he exposes himself to refutation and the better he does his job. But beyond this the dance public wants him to be influential in raising the level of dance production in their community; to be enlightening on general questions of theater dancing, its heritage, and its current innovations; and to awaken an interest for dancing in intelligent readers who are not dance fans already.

What awakens the interest of an intelligent reader in a dance column is to find it written in good English. Even if he is not used to thinking about dancing he can follow a discussion that makes its point through a vivid picture of what actually happens onstage. On the other hand he loses interest if a dance column offers him only the same vague clichés he has already read elsewhere in the paper. After reading a movie review or a political commentator he is not thrilled to find that a ballet, too, is challenging, vital, significant (significant of what? challenging or vital to whom?). When a ballet is called earthy he recognizes the term as a current synonym for commercial-minded. Inappropriate visual images are suggested to him when he reads that a dance is meaty; or that dancers onstage were rooted in the soil and clung bravely to their roots;

or that young choreographers are to be admired for their groping. No sensible person can want to watch a dancer brooding over a culture, or filling her old form with a new content, or even being stunningly fertile; or if he wants to watch, it isn't because of the dancing.

Our unspecialized dance reporters can't in sensible terms tell the public what is interesting and original in current dancing. Since 1942, for instance, strict classic ballet has become widely appreciated and acclimated in this country. It has changed so far from the prewar Ballet Russe manner that it has now a new and American flavor. But the nation's dance journalists have been notably unenlightening on the subject of classicism, its meaning, and its new development (some journalists even confuse classicism with stylized movement). To take another example, in the same period the modern dance has been trying for a new style, a new rhythm, and a different sort of theater appeal than before. Various aspects of the change have been due to Martha Graham's example, to her own shift in technique, to a new supply of male dancers, to the party line, and to contact with ballet; a new modern style shows particularly in the work of Shearer and of Cunningham. The nation's press knows that something has happened to our dancing in the last five or six years, but it doesn't yet know what.

During the same period the nation's press has not demonstrated its influence for raising production standards either. All the New York critics together, for instance, have been unable to reform the miserable ballet

company of the Metropolitan Opera. Neither they nor their colleagues elsewhere have been able to get the big ballet companies to keep fresh and clean the good productions (like *Romeo*) or purge the hopeless ones (like *Schéhérazade*). They have been unable to arrest the recent (1946–1947) deterioration of dance standards, to protect dancers from being exhausted by overwork or demoralized by slipshod artistic policies. They have not ridiculed the illiterate English on ballet programs. They have even been unable to keep unmannerly latecomers in the audience from clambering over the rest of the public in the dark or to shush the bobby-soxers and showoffs who brutally interrupt a dance scene by applauding in a frenzy at any passable leap or twirl. If dance critics are meant to function as watchdogs of the profession they review, they will have to have sharper teeth and keener noses, too.

If only another half-dozen specialized and intelligent dance critics were writing in metropolitan papers, the public all over the country would profit considerably. Not that well-informed critics would agree on all detail—far from it—but they could with a sharper authority insist on an improved general level of current production.

A special question of dance journalism is its usefulness to the choreographers and dancers who are reviewed. The point concerns few newspaper readers, but those it agitates bitterly. Ignorant criticism is naturally resented by professionals; but intelligent criticism when adverse often is, too. All critics would like very much to be helpful to a good artist. They love the art they review

and everyone who contributes to it; they know the many risks of the profession. They are constantly trying to help, but the occasions when they are actually helpful seem to be happy accidents.

The professionals of the dance world are of course the most eager readers of dance reviewing, but they do not read their own reviews very rationally. For one thing a poor notice upsets them the way an insult does other people. For another, they argue that it endangers their future jobs. But in the touring repertory system of ballet the critics do not "make or break" a ballet or a dancer; managers do. To a dancer's career a bad notice is a much less serious occupational hazard than a poor figure, laziness, poor hygiene, tactlessness toward fellow professionals, or solipsistic megalomania—none of which a dancer who suffers from them complains of nearly so loudly.

A choreographer or a dancer, as he reads his notices, often forgets that they are not addressed to him personally but are a report to the general public. They are a sort of conversation between members of the audience on which the artist eavesdrops at his own emotional risk. What he overhears may make no sense to him; it may shock or intoxicate him; but it is astonishing how rarely, how very rarely it is of any use to him in his actual creative activity. It will sometimes corroborate a guess of his own, but it is generally silent on points he feels vital. Reviews cannot replace his own conscience, much less his driving instinct. A great dancer after twenty years of celebrity spoke of two reviews that had been valuable.

In my opinion reading reviews about oneself is a waste of time, like smoking cigarettes. To read reviews of rivals is more likely to be of use. Hardworking artists are refreshed by a rave for their "art," whether it makes sense or not, but blame is exhausting to deal with. Serious professionals often limit the value of reviews to the recognition of good craftsmanship and of technical innovations; and according to Virgil Thomson—great artist and great critic, too—opinions beyond the recognition of these facts are pure fantasy. But for the audience—to whom the critic reports—the fantasy spell of art is that of conscious device multiplied by unconscious meaning. As long as the critic's fantasy remains intelligible to read, its forces and its scope are what give the reader a sense of the power and value of the work reviewed.

An intelligent reader learns from a critic not what to think about a piece of art but how to think about it; he finds a way he hadn't thought of using. The existence of an "authoritative critic" or a "definitive evaluation" is a fiction like that of a sea serpent. Everybody knows the wild errors of judgment even the best critics of the past have made; it is easier to agree with contemporary judgments but no more likely they are right. It seems to me that it is not the critic's historic function to have the right opinions but to have interesting ones. He talks but he has nothing to sell. His social value is that of a man standing on a street corner talking so intently about his subject that he doesn't realize how peculiar he looks doing it. The intentness of his interest makes people who

don't know what he's talking about believe that whatever it is, it must be real somehow—that the art of dancing must be a real thing to some people some of the time. That educates citizens who didn't know it and cheers up those who do.

When people who like dancing say a critic is right they mean he is right enough and that his imaginative descriptions are generally illuminating. He can hardly be illuminating or right enough unless he has a fund of knowledge about his subject. In theory he needs to know the techniques and the historical achievements of dancing, the various ways people have looked at it and written about it, and finally he needs a workable hypothesis of what makes a dance hang together and communicate its images so they are remembered. In practice he has to piece together what he needs to know; experience as a dancer and choreographer is an invaluable help to him.

The best organized and by far the most useful chunk of knowledge a critic has access to is that about the technique and history of classic ballet, in particular as ballet dancers learn it. Its gymnastic and rhythmic technique is coherent enough to suggest principles of dance logic—as expressive human movement in musical time and architectural space. But so far the best informed of specialized ballet critics have not formulated these clearly. And French ballet criticism as a whole, though it has had for several centuries nearly all the best dancing in the world to look at, though it has since as far back as 1760 (since Noverre's *Letters*) a brilliant lesson in how

to write about dancing, hasn't yet been able to bring order and clarity to the subject. Though they have been writing steadily for two centuries and more—and often writing pleasantly—the Paris critics have left us as reporters no accurate ballet history, as critics no workable theory of dance emphasis, of dance form, or of dance meaning.

The handicap to method in dance criticism has always been that its subject matter—dancing that can fascinate as an art does—is so elusive. Other arts have accumulated numerous wonderfully fascinating examples in many successive styles. Dancing produces few masterpieces and those it does are ephemeral. They can't be stored away; they depend on virtuoso execution, sometimes even on unique interpreters. They exist only in conjunction with music, stage architecture, and decoration in transitory, highly expensive performances. It is difficult to see the great dance effects as they happen, to see them accurately, catch them so to speak in flight, and hold them fast in memory. It is even more difficult to verbalize them for critical discussion. The particular essence of a performance, its human sweep of articulate rhythm in space and in time, has no specific terminology to describe it by. Unlike criticism of other arts, that of dancing cannot casually refer the student to a rich variety of well-known great effects and it cannot quote passages as illustrations.

This lack of precision, of data, and of method is not without advantages. It saves everyone a lot of pedantry

and academicism, and it invites the lively critic to invent most of the language and logic of his subject. Its disadvantages, however, are that it makes the standards of quality vague, the range of achieved effects uncertain, and the classification of their component parts clumsy. Dance aesthetics, in English especially, is in a pioneering stage; a pioneer may manage to plant a rosebush in his wilderness next to the rhubarb, but he's not going to win any prizes in the flower show back in Boston.

The aesthetics of dancing—that is, a sort of algebra by which the impression a performance makes can be readily itemized, estimated, and communicated to a reader—is vague and clumsy. The dance critic's wits have to be all the sharper; he has to use aesthetic household wrinkles and aesthetic common sense to help out. And he has to pull his objectivity out of his hat. The poverty of his dance-critical heritage makes it hard for him to get a good view of his personal blind spots. A critic in the other arts learns to recognize his blind spots and develop his special gifts by finding out how he personally reacts to a wide range of much-discussed masterpieces. If he is annoyed by Mozart or Vermeer or even by Picasso and Stravinsky, he can read intelligent opinions different from his own. That way he learns who he is, what he knows and doesn't know. Gaps and crudities of critical technique are of concern to a professional critic; they are questions of his craft.

The earnest craftsman must hope that once a dance notation has become established, once the various

hints toward a critical method (including those by modern-dance theoreticians and of exotic traditions) have been collected, sifted, and codified, dance critics will seem brighter than they do now.

At present a critic has to risk hypothesis. He can try, for instance, to distinguish in the complex total effect of a performance the relationships between dance effect and story effect, between expressive individualized rhythm and neutral structural rhythm, dance impetus and pantomime shock, dance illusion and dance fun, sex appeal and impersonation, gesture which relates to the whole architectural space of the stage and has an effect like singing and gesture which relates to the dancer's own body and so has the effect of a spoken tone. And there are of course many possible relationships of the dancing to the structure or momentum of the music which, by creating in the visual rhythm illusions of lightness and weight, impediment or support (for instance), affect the meaning of a passage. Dance criticism would be clearer if it found a way to describe these and other relationships in theater effect, and to describe just what the dancers' bodies do, the trunk, legs, arms, head, hands, and feet in relation to one another. The expression of a reviewer's personal reaction, no matter how violent or singular, becomes no immodesty when he manages to make distinct to the reader the visible objective action onstage he is reacting to.

Nowadays, however, a critic doesn't screen a dance performance according to such distinctions. What he

actually does is to work backward, so to speak, from the dance image that after the event is over strikes him as a peculiarly fascinating one. He tries to deduce from it a common denominator in what he saw—a coherent principle, that is, among uncertainly remembered, partly intense, partly vague, partly contradictory images. It takes boldness to simplify his impressions so they add up clearly to a forthright opinion; and it sometimes takes a malicious sense of fun, too, to trust his instinct where he knows he is risking his neck. But the intelligent reader need not be at all sorry that dance criticism is in a rudimentary or pioneering stage. It makes it more inviting to poets than to schoolteachers; and though its problems and possible discoveries are not colossal ones, still—if it succeeds in attracting poets—it should be for a century or so to come fun to write and to read.

An intelligent reader expects the critic—in his role of schoolteacher—to distinguish between good and bad dance technique, to distinguish between good and bad choreographic craftsmanship, to specify technical inventions and specify also the gifts that make a choreographer or a dancer remarkable despite defects in craftsmanship. Here the writer shows his fairness. But what one enjoys most in reading is the illusion of being present at a performance, of watching it with an unusually active interest and seeing unexpected possibilities take place. Reading a good critic's descriptions of qualities I have seen, I seem to see them more clearly. If I don't know them, I try looking for them in performances I

remember or try to find them next time I go to the theater. And when you look for qualities a reviewer has mentioned, you may find something else equally surprising. For your sharpened eye and limberer imagination is still a part of your own identity—not of his—and leads you to discoveries of your own. The fun in reading dance criticism is the discovery of an unexpected aspect of one's own sensibility.

In reading the great ballet critics of the past, one is impressed not by their fairness but by their liveliness. In reading Noverre or Gautier or Levinson, I find accounts that strike me as so unlikely I interpret them—by analogy to contemporaries—as blind spots, or propaganda and rhetoric; even if some of these accounts are accepted as facts of dance history. But it is not the partisan spirit with which they can blindly propagandize their own aesthetic views that differentiates them from lesser critics; it is the vividness of their descriptions that is unique. Gautier, who of the three gives a reader the most immediate sense of the sensuous fluidity and physical presence of ballet, expresses theory in terms of chitchat and ignores choreographic structure and technical talk. He seems to report wholly from the point of view of a civilized entertainment seeker; the other two, from the backstage point of view of the craftsman as well.

Noverre and Levinson advance theories of dance expression which are diametrically opposite. The force with which they are formulated gives their writing an elevation Gautier avoids, but makes them both far easier

than he to misunderstand. Here in a nutshell is the dance critic's problem: the sharper he formulates a theory of the technique of expression, of how dance communicates what it does, the further he gets from the human vivacity of dancing without which it communicates nothing at all. And yet it is difficult to consider the central question of dancing—I mean, the transport and sweep that dance continuity can achieve, the imaginative radiance some moments of dancing are able to keep for years in people's memory, the central questions Balanchine in his illuminating "Notes on Choreography" brings up in speaking of "basic movements"—unless the critic finds some way to generalize and to speak vividly of general as well as of particular dance experience.

I trust a future critic will be well informed enough to discuss such generalized principles of dance expression clearly. He could begin by clarifying our specific ballet tradition—the tradition called classic because its expressive intentions and technical precisions were long ago in some sort modeled on the achievements of ancient classic literature. It seems to me the elements of this theater-dance tradition, if they were vividly appreciated, are various enough to include in one set of critical values both what we call the modern dance and our present classic ballet—though at the moment the two are far apart in their gymnastic, rhythmic, and expressive structure and in their theater practicability as well. It seems to me that a vivid sense of such an inclusive tradition would set the merits of a choreographer or of a dancer

in a larger perspective and would offer a way of describing his scope as craftsman and as artist in the light of all the achievements of past theater dancing.

So I should like to read a critic who could make me appreciate in dancing the magic communal beat of rhythm and the civilized tradition of a personal and measured communication. I expect him to sharpen my perception sometimes to an overall effect, sometimes to a specific detail. I should not be surprised to find in some of his descriptions general ideas stimulating in themselves, even apart from his immediate subject, nor to find in other descriptions technical terms of dancing, of music, of painting or theater craft. I should like him to place a choreography or a dancer with his individual derivations and innovations in the perspective of the tradition of theater dancing. I am far more interested, though, if a writer is able, in describing dancing in its own terms, to suggest how the flavor or the spell of it is related to aspects of the fantasy world we live in, to our daily experience of culture and of custom; if he can give my imagination a steer about the scope of the meaning it communicates. But as I read I want to see, too, the sensual brilliance of young girls and boys, of young men and women dancing together and in alternation onstage, the quickness and suavity of their particular bodies, their grace of response, their fervor of imagination, the boldness and innocence of their flying limbs.

A writer is interesting if he can tell what the dancers did, what they communicated, and how remarkable that

was. But to give in words the illusion of watching dancers as they create a ballet in action requires a literary gift. An abstruse sentence by Mallarmé, the rhythmic subtlety of a paragraph by Marianne Moore, a witty page-long collage of technical terms by Goncourt can give the reader a sharper sense of what dancing is about than a book by an untalented writer, no matter how much better acquainted with his subject he is. Such examples lead to fallacious conclusions, but I am drawing no conclusions, I am stating a fact. A dance critic's education includes dance experience, musical and pictorial experience, a sense of what art in general is about and what people are really like. But all these advantages are not enough unless they meet with an unusual literary gift and discipline.

Now and then in reading dance criticism one comes across a phrase or a sentence that suggests such an ideal possibility. It is to emphasize these passages to people who wonder what good dance criticism is that I am writing. The fact that no criticism is perfect doesn't invalidate its good moments. Granted it is brilliant far less often than the dancing it commemorates; the fact that it is after all occasionally brilliant is what makes it as a form of intellectual activity in a modest way worthwhile.

The Dance Encyclopedia, 1949

The Climate

I myself like the climate of New York
I see it in the air up between the street
You use a worn-down cafeteria fork
But the climate you don't use stays fresh and neat.
Even we people who walk about in it
We have to submit to wear too, get muddy,
Air keeps changing but the nose ceases to fit
And sleekness is used up, and the end's shoddy.
Monday, you're down; Tuesday, dying seems a fuss
An adult looks new in the weather's motion
The sky is in the streets with the trucks and us,
Stands awhile, then lifts across land and ocean.
We can take it for granted that here we're home
In our record climate I look pleased or glum.

The Subway

The subway flatters like the dope habit,
For a nickel extending peculiar space:
You dive from the street, holing like a rabbit,
Roar up a sewer with a millionaire's face.

Squatting in the full glare of the locked express
Imprisoned, rocked, like a man by a friend's death,
O how the immense investment soothes distress,
Credit laps you like a huge religious myth.

It's a sound effect. The trouble is seeing
(So anaesthetized) a square of bare throat
Or the fold at the crotch of a clothed human being:
You'll want to nuzzle it, crop at it like a goat.

That's not in the buy. The company between stops
Offers you security, and free rides to cops.

Standing on the Streetcorner

Looking north from 23rd the vast avenue
—A catastrophic perspective pinned to air—
Here has a hump. Rock underneath New York though
Is not a subject for which people do care.
But men married in New York or else women
Dominate the pavement from where they stand,
Middle-age distends them like a vast dream
While boys and girls pass glancing to either hand.
Sly Carolina, corny California
Peculiar Pennsylvania, waiting Texas
You say what you say in two ways or one way
Familiar with light-reflecting surfaces.
Time in every sky I look at next to people
Is more private than thought is, or upstairs sleeping.

City without Smoke

Over Manhattan island when gales subside
Inhuman colors of ocean afternoons
Luminously livid, tear the sky so wide
The exposed city looks like deserted dunes.
Peering out to the street New Yorkers in saloons
Identify the smokeless moment outside
Like a subway stop where one no longer stirs. Soon
This oceanic gracefulness will have died.
For to city people the smudgy film of smoke
Is reassuring like an office, it's sociable
Like money, it gives the sky a furnished look
That makes disaster domestic, negotiable.
Nothing to help society in the sky's grace
Except that each looks at it with his mortal face.

The Silence at Night

(The designs on the sidewalk Bill pointed out)

The sidewalk cracks, gumspots, the water, the bits
 of refuse,
They reach out and bloom under arclight, neonlight—
Luck has uncovered this bloom as a by-produce
Having flowered too out behind the frightful stars
 of night.
And these cerise and lilac strewn fancies, open to bums
Who lie poisoned in vast delivery portals,
These pictures, sat on by the cats that watch the slums,
Are a bouquet luck has dropped here suitable to mortals.
So honey, it's lucky how we keep throwing away
Honey, it's lucky how it's no use anyway
Oh honey, it's lucky no one knows the way
Listen chum, if there's that much luck then it don't pay.
The echoes of a voice in the dark of a street
Roar when the pumping heart, bop, stops for a beat.

First Warm Days

April, up on a twig a leaftuft stands
And heaven lifts a hundred miles mildly
Comes and fondles our faces, playing friends—
Such a one day often concludes coldly—
Then in dark coats in the bare afternoon view
Idle people—we few who that day are—
Stroll in the park aimless and stroll by twos
Easy in the weather of our home star.
And human faces—hardly changed after
Millennia—the separate single face
Placid, it turns toward friendly laughing
Or makes an iridescence, being at peace.
We all are pleased by an air like of loving
Going home quiet in the subway-shoving.

21

from A Sonnet Sequence

The street is where people meet according to law
Organize their natures to twenty-four hours
Say what to eat, take advantage of what they saw
And continue exercising daily powers.

Take one of these buildings, when standing awhile
The architect's headaches have been written right off
Just as a father's headaches amount to a smile
Like a cipher, when he gets the client to laugh.

So a million people are a public secret
(As night is a quieter portion of the day)
These are their private lives tearing down the street
Stepping past mouldings and past 'Special Today.'

Running they see each other without looking,
Love has not stopped, has not started by fucking.

Aaron

Aaron had a passion for the lost chord. He looked for it under the newspapers at the Battery, saying to himself, "So many things have been lost." He was very logical and preferred to look when nobody was watching, as anyone would have, let us add. He was no crank, though he was funny somehow in his bedroom. He was so funny that everybody liked him, and hearing this those who had been revolted by him changed their minds. They were right to be pleasant, and if it hadn't been for something making them that way, they wouldn't have been involved in the first place. Being involved of course was what hurt. "It's a tight squeeze," Aaron was saying in his bedroom, and let us suppose he was quite right. He closed his eyes and shivered, enjoying what he did. And he went on do-ing it, until it was time for something else, saying "I like it." And he did. He liked a good tune too, if it lasted. He once remarked to somebody, "Tunes are like birds." He wanted to say it again, but he couldn't remember, so the conversation became general, and he didn't mind. What was Aaron's relationship to actuality? I think it was a very good relationship.

Indiana

Mary went in little smiles
meant a little brighter
anyone without the piles
could frighten or delight her.

Ethel's mother makes the air
with peas and pins and panties
several boys were never there
giggling in their shanties.

I wonder if Father is coming,
I wonder if Father has gone,
strumming and thumbing and bumming
with an ice-cream cone for me.

Sister bought herself a squat
—could she have the knife—
hung her curtain cross the lot
at her time of life.

Held

The bright young bones growing turn like green tendrils
but bright in the dark, but turning in slow young years
or like the bright flight of birds curving stilly
still almost and held by the mind's variable speed

In the mind's variable speed the young light body
and the green light hovering on fair sleeping hair
and the birdlike curve of too long limbs, wholly
held, turn in their slow darkness of yearning years.

Another Legend

A child singing to itself in the sunlight
Among the debris of New York likes a man's
Listening; and the other way round too is right;
Rarely, though in ruins, the two sing at once.
The gift either has is defenseless—pink
Of a child's mouth, repose of a man's hope,
Into the open day will vanish and sink;
Soldier and child, one drifts away, one vacant mopes.
Luck returns over and over in a long
Life. A child's beauty by electric light
Is muddied, but not theatrical song.
The President attends the opera tonight.
But death, listening in the wings to the painted
Singer, notes a weakness we take for granted.

On Meaning in Dance

Any serious dance work has an element of pantomime and an element of straight dance, with one or the other predominant. When you think about it, it is curious in how different a way the two elements appeal to the intelligence, how differently they communicate a meaning.

Tudor's *Pillar of Fire* is a brilliant example of contemporary pantomime ballet. It is as absorbing to us as Fokine's *Schéhérazade* was to our parents in its 1910 version thirty years ago. The difference between the two is striking: *Schéhérazade* was bright and luscious, *Pillar of Fire* is gloomy and hot; Fokine hacked at his subject with a cleaver, Tudor dissects his with a scalpel. But—apart from the big orgy they each work up to—the two ballets both hold the attention by a continuous, clear story. Both belong to the tradition of the stylized drama, and not (as *Coppélia* and *Ballet Imperial* do) to the tradition of the dance entertainment. The pantomime ballet focuses the attention on stylized movement; the dance ballet, on a suite of dances.

What is a "stylized movement"? It is a movement that looks a little like dancing but more like nondancing. It is a movement derived from what people do when they are not dancing. It is a gesture from life deformed to suit music (music heard or imagined). The pleasure of watching it lies in guessing the action it was derived from, in guessing what it originally looked like, and then in savoring the "good taste" of the deformation.

Stylized movement has always been a perfectly legitimate pleasure in the theater. Sometimes it's merely a little quiz game thrown in for variety. In general, though, a stylized passage adds a pretty color to any dance. And stylization is one of the best recipes for a comic effect.

But in the pantomime ballet, stylized movement is the main aspect of expression. It is what one looks at particularly, because it keeps making a serious dramatic point. Gesture by gesture, as if idea by idea, the drama is built up. The audience watches for each allusion in turn; it follows point by point. The interest becomes like that of a detective story. The audience peers eagerly, delighted to have caught on, anxious not to miss a clue. It solves harder and harder riddles. The storytelling gathers momentum: as in driving a car, it's the speed that is thrilling, not the incidental scenery. One is, so to speak, hypnotized by the future destination. One merely wants to know what happened, as in watching a motion picture.

On the other hand, a dance ballet (*Coppélia*, for example) has a very different kind of appeal. True, it also has a story and it has pantomime portions. But you don't take them seriously. The parts that show you the heart of the subject, that are the most expressive, are in the form of dance numbers, of dance suites. They are like arias in an opera. In a dance ballet the story is not a pressing one, and it can be delayed a while for a lyric comment on the momentary situation. The audience has come to enjoy the dancing; it is in no hurry to get the heroine married or murdered and to be sent out of the theater again.

In a dance ballet there is a difference in the way the audience watches the movement. It does not identify the gestures with references to real life; it does not search in each pose for a distinct descriptive allusion. It watches the movements in sequence as a dance. There is a sort of suspension in judgment, a wait and a wonder till the dance is completed, till the dancer has come to rest. When the dance is over one understands it as a whole; one understands the quality of the dancer's activity, the quality of her rest, and in the play between the two lies the meaning of the dance aria, the comment it has made on the theme of the ballet. One has understood the dance as one does a melody—as a continuity that began and ended. It is a nonverbal meaning, like the meaning of music.

The dancer in pantomime emphasizes what each of the gestures looks like, he appeals pictorially to intellectual concepts. The dancer in a dance number emphasizes the kinetic transformation, his dance is a continuity which moves away from one equilibrium and returns to another. Repose is as important to the meaning of a dance ballet as activity. But in pantomime a stop must be made to look active and pressing, it must keep the urgency of the history. This difference leads the dancer to a different emphasis in technique.

New York Herald Tribune, July 18, 1943

Against Meaning in Ballet

Some of my friends who go to ballet and like the entertainment it gives are sorry to have it classed among the fine arts and discussed, as the other fine arts are, intellectually. Though I do not agree with them I have a great deal of sympathy for their anti-intellectual point of view. The dazzle of a ballet performance is quite reason enough to go; you see handsome young people—girls and boys with a bounding or delicate animal grace—dancing among the sensual luxuries of orchestral music and shining stage decoration and in the glamour of an audience's delight. To watch their lightness and harmonious ease, their clarity and boldness of motion, is a pleasure. And ballet dancers' specialties are their elastic tautness, their openness of gesture, their gaiety of leaping, beating, and whirling, their slow soaring flights. Your senses enjoy directly how they come forward and closer to you, or recede upstage, turning smaller and more fragile; how the boys and girls approach one another or draw apart, how they pass close without touching or entwine their bodies in stars of legs and arms—all the many ways they have of dancing together. You see a single dancer alone showing her figure from all sides deployed in many positions, or you see a troop of them dancing in happy unison. They are graceful, well mannered, and they preserve at best a personal dignity, a civilized modesty of deportment that keeps the sensual stimulus from being foolishly cute or commercially sexy.

The beauty of young women's and young men's bodies, in motion or in momentary repose, is exhibited in an extraordinarily friendly manner.

When you enjoy ballet this way—and it is one of the ways everybody does enjoy it who likes to go—you don't find any prodigious difference between one piece and another, except that one will have enough dancing to satisfy and another not enough, one will show the dancers to their best advantage and another will tend to make them look a little more awkward and unfree. Such a happy ballet lover is puzzled by the severities of critics. He wonders why they seem to find immense differences between one piece and another, or between one short number and another, or between the proficiency of two striking dancers. The reasons the critics give, the relation of the steps to the music, the sequence of the effects, the sharply differentiated intellectual meaning they ascribe to dances, all this he will find either fanciful or plainly absurd.

Has ballet an intellectual content? The ballet lover with the point of view I am describing will concede that occasionally a soloist gives the sense of characterizing a part, that a few ballets even suggest a story with a psychological interest, a dramatic suspense, or a reference to real life. In such a case, he grants, ballet may be said to have an intellectual content. But these ballets generally turn out to be less satisfying to watch because the dancers do less ballet dancing in them; so, he concludes, one may as well affirm broadly that ballet does not prop-

erly offer a "serious" comment on life and that it is fool-
ish to look for one.

I do not share these conclusions, and I find that my
interest in the kind of meaning a ballet has leads me to
an interest in choreography and dance technique. But I
have a great deal of sympathy for the general attitude I
have described. It is the general attitude that underlies
the brilliant reviews of Théophile Gautier, the French
poet of a hundred years ago, who is by common con-
sent the greatest of ballet critics. He said of himself that
he was a man who believed in the visible world. And his
reviews are the image of what an intelligent man of the
world saw happening on the stage. They are perfectly
open; there is no private malignity in them; he is neither
pontifical nor "popular"; there is no jargon and no ulte-
rior motive. He watches not as a specialist in ballet, but
as a responsive Parisian. The easy flow of his sentences
is as much a tribute to the social occasion as it is to the
accurate and elegant ease of the ballet dancers in action.
His warmth of response to personal varieties of grace
and to the charming limits of a gift, his amusement at
the pretensions of a libretto or the pretensions of a star,
his sensual interest in the line of a shoulder and bosom,
in the elasticity of an ankle, in the cut of a dress, place the
ballet he watches in a perspective of civilized good sense.

Ballet for him is an entertainment—a particularly
agreeable way of spending an evening in town; and bal-
let is an art, it is a sensual refinement that delights the
spirit. Art for him is not a temple of humanity one enters

with a reverent exaltation. Art is a familiar pleasure and Gautier assumes that one strolls through the world of art as familiarly as one strolls through Paris, looking about in good weather or bad, meeting congenial friends or remarkable strangers, and one's enemies, too. Whether in art or in Paris, a civilized person appreciates seeing a gift and is refreshed by a graceful impulse; there is a general agreement about what constitutes good workmanship; and one takes one's neighbors' opinions less seriously than their behavior. Gautier differentiates keenly between good and bad ballet; but he differentiates as a matter of personal taste. He illustrates the advantages the sensual approach to ballet can have for an intelligence of exceptional sensual susceptibility and for a man of large sensual complacency.

Gautier assumes that all that people need do to enjoy art is to look and listen with ready attention and trust their own sensual impressions. He is right. But when they hear that ballet is an elaborate art with a complicated technique and tradition, many modest people are intimidated and are afraid to trust their own spontaneous impressions. They may have been to a few performances, they may have liked it when they saw it, but now they wonder if maybe they liked the wrong things and missed the right ones. Before going again, they want it explained, they want to know what to watch for and exactly what to feel. If it is really real art and fine great art, it must be studied before it is enjoyed; that is what they remember from school. In school the art of po-

etry is approached by a strictly rational method, which teaches you what to enjoy and how to discriminate. You are taught to analyze the technique and the relation of form to content; you are taught to identify and "evaluate" stylistic, biographical, economic, and anthropological influences, and told what is great and what is minor so you can prepare yourself for a great reaction or for a minor one. The effect of these conscientious labors on the pupils is distressing. For the rest of their lives they can't face a page of verse without experiencing a complete mental blackout. They don't enjoy, they don't discriminate, they don't even take the printed words at face value. For the rest of their lives they go prying for hidden motives back of literature, for psychological, economic, or stylistic explanations, and it never occurs to them to read the words and respond to them as they do to the nonsense of current songs or the nonsense of billboards by the roadside. Poetry is the same thing—it's words, only more interesting, more directly and richly sensual.

The first taste of art is spontaneously sensual, it is the discovery of an absorbing entertainment, an absorbing pleasure. If you ask anyone who enjoys ballet or any other art how he started, he will tell you that he enjoyed it long before he knew what it meant or how it worked. I remember the intense pleasure reading Shelley's *Adonais* gave me as a boy—long before I followed accurately the sense of the words; and once, twenty years later, I had two kittens who would purr in unison and watch me bright-eyed when I read them Shakespeare's

sonnets, clearly pleased by the compliment and by the sounds they heard. Would they have enjoyed them better if they had understood them? The answer is, they enjoyed them very much. Many a college graduate might have envied them.

I don't mean that so orderly and respectable an entertainment as that of art is made for the susceptibilities of kittens or children. But consider how the enormous orderly and respectable symphonic public enjoys its listening, enjoys it without recognizing themes, harmonies, or timbres, without evaluating the style historically or even knowing if the piece is being played as the composer intended. What do they hear when they hear a symphony? Why, they hear the music, the interesting noises it makes. They follow the form and the character of it by following their direct acoustic impressions.

Susceptibility to ballet is a way of being susceptible to animal grace of movement. Many people are highly susceptible to the pleasure of seeing grace of movement who have never thought of going to a ballet to look for it. They find it instead in watching graceful animals, animals of many species at play, flying, swimming, racing, and leaping and making gestures of affection toward one another, or watchful in harmonious repose. And they find it, too, in seeing graceful young people on the street or in a game or at the beach or in a dance hall, boys and girls in exuberant health who are doing pretty much what the charming animals do, and are as unconscious of their grace as they. Unconscious grace of movement is

a natural and impermanent gift, like grace of features or of voice or of character, a lucky accident you keep meeting with all your life wherever you are. To be watching grace puts people into a particularly amiable frame of mind. It is an especially attractive form of feeling social consciousness.

But if ballet is a way of entertaining the audience by showing them animal grace, why is its way of moving so very unanimal-like and artificial? For the same reason that music has evolved so very artificial a way of organizing its pleasing noises. Art takes what in life is an accidental pleasure and tries to repeat and prolong it. It organizes, diversifies, characterizes, through an artifice that men evolve by trial and error. Ballet nowadays is as different from an accidental product as a symphony at Carnegie Hall is different from the noises Junior makes on his trumpet upstairs or Mary Ann with comb and tissue paper, sitting on the roof, the little monkey.

You don't have to know about ballet to enjoy it; all you have to do is look at it. If you are susceptible to it, and a good many people evidently are, you will like spontaneously some things you see and dislike others, and quite violently, too. You may be so dazzled at first by a star or by the general atmosphere, you don't really know what happened; you may on the other hand find the performance absurdly stiff and affected except for a few unreasonable moments of intense pleasure; but if you are susceptible you will find you want to go again. When you go repeatedly, you begin to recognize what it is you

like, and watch for it the next time. That way you get to know about ballet, you know a device of ballet because you have responded to it, you know that much at least about it. Even if nobody agrees with you, you still know it for yourself.

That the composite effect of ballet is a complex one is clear enough. Its devices make a long list, wherever you start. These devices are useful to give a particular moment of a dance a particular expression. The dancers in action give it at that moment a direct sensual reality. But if you watch often and watch attentively, the expressive power of some ballets and dancers will fascinate, perturb, and delight far more than that of others, and will keep alive in your imagination much more intensely long after you have left the theater. It is this aftereffect that dancers and ballets are judged by, by their audience.

To some of my friends the images ballet leaves in the imagination suggest, as poetry does, an aspect of the drama of human behavior. For others such ballet images keep their sensual mysteriousness, "abstract," unrationalized, and magical. Anyone who cannot bear to contemplate human behavior except from a rationalistic point of view had better not try to "understand" the exhilarating excitement of ballet; its finest images of our fate are no easier to face than those of poetry itself, though they are no less beautiful.

Ballet, March 1949

Ballet Technique

When they watch a ballet in the theater, some people can take ballet technique for granted as easily as school kids take the technique of basketball for granted while they watch a lively game in a gym. These ballet lovers see the dance impulses perfectly clearly.

Other people, however, are bothered by the technique. They watch the gestures without feeling the continuity of the dance; the technique seems to keep getting in the way of it. Ballet looks to them chiefly like a mannerism in holding the arms and legs, and in keeping the back stiff as a ramrod. They can see it must be difficult to move about in that way, but why try in the first place? Annoyed at the enthusiasm of their neighbors in the theater, they come to the conclusion that ballet technique is a snobbish fad, the perverse invention of some dead and forgotten foreign aesthetic dictator who insisted on making dancing as unnatural as possible.

But ballet technique isn't as unreasonable as that. Just as a dazzling technique in pitching, for instance, is an intelligent refinement of throwing a ball for fun (which everybody does somehow), so ballet technique is a refinement of social dancing and folk dancing, a simple enough thing that everybody has tried doing for fun in his own neighborhood. You know the main technical problem of dancing the first time you try; it's to move boldly without falling flat on the dance floor. You have to get the knack of shifting your weight in a peculiar way.

Next you try to keep in rhythm, and then you try to give the conventional steps that extra personal dash which makes the dance come off. It's a question, of course, of doing all this jointly with others, sometimes in groups, sometimes in couples—when a little sex pantomime may be added, by common consent all over the world. And incidental acrobatic feats are welcome if they don't break up the dancers' happy sense of a collective rhythm.

Exhibition dance technique is a way of doing the same things for the pleasure of the neighbors who gather to watch. You see the simple elements of common dance technique refined and specialized, with a particular emphasis placed on one element or another. In recent generations we have seen our own normal folk and social dances evolve into professional tap dancing, into exhibition ballroom, and most recently into exhibition lindy.

Like these recent dance techniques, ballet, too, is the result of practical experiments by a number of exhibition dancers—a long line of professionals which in the case of ballet began in the seventeenth century and has not yet ended. The ballet dancers seem to have taken as their point of emphasis not the small specialty tricks but the first great problem everybody has in dancing—the trouble of keeping in balance. The problem might be described as that of a variable force (the dance impulses) applied to a constant weight (the body). The ballet technicians wanted to find as many ways as possible of changing the impetus of the movement without losing control of the momentum of the body. When a

dancer is not sure of his momentum he is like a driver who has no rhythm in driving, who jolts you, who either spurts or dawdles and makes you nervous. Watching a dancer whose momentum is under control, you appreciate the change in impetus as an expression. You follow the dance with pleasure, because the dancer has your confidence.

The foot, leg, arm, and trunk positions of ballet, the way it distributes the energy in the body (holding back most of it in the waist and diminishing it from there as from a center)—this is a method of keeping the urgency of the movement in relation to a center of gravity in the body. The peculiar look of ballet movement is not the perverse invention of some dead aesthetic dictator. It is a reasonable method which is still being elaborated by experiment. On the basis of a common technical experience—that of equilibrium in motion—this method tries to make the changes of impulse in movement as distinctly intelligible as possible. There have always been great dancers who danced in other techniques than that of ballet. But there have always been great dancers, too, who found in ballet technique an extraordinary range of clear expression.

New York Herald Tribune, July 25, 1943

Notes on Nijinsky Photographs

Looking at the photographs of Nijinsky, one is struck by his expressive neck. It is an unusually thick and long neck. But its expressivity lies in its clear lift from the trunk, like a powerful thrust. The shoulders are not square, but slope downward; and so they leave the neck easily free, and the eye follows their silhouette down the arms with the sense of a line extraordinarily extended into space, as in a picture by Cezanne or Raphael. The head therefore, at the other end of this unusual extension, poised up in the air, gains an astonishing distinctness, and the tilt of it, even with no muscular accentuation, becomes of unusual interest. Nijinsky tilts his head lightly from the topmost joint, keeping this joint mobile against the upright thrust of the other vertebrae. He does not bend the neck back as some contemporary ballet dancers do. Seen from the side or the rear, the upward line of his back continues straight into the uprightness of the neck, like the neck of a Maillol statue. But Nijinsky alters his neck to suit a character role. The change is striking in the *Schéhérazade* pictures—and Mr. Van Vechten, who saw him dance the part, describes him as a "head-wagging, simian creature." Another variation is that for *Petrouchka*, where the shoulders are raised square to break the continuity of the silhouette; to make the arms dangle as a separate entity, and make the head independently wobbly as a puppet's is, on no neck to speak of. The head here does not sum up or direct the

Vaslav Nijinsky as Petrouchka, 1913

action of the body; it seems to have only a minor, a pathetic function. But it bobs too nonsensically to be humanly pitiful. In the role of the Faun the shoulders are slightly lifted when the Faun becomes dimly aware of his own emotion; but the neck is held up firmly and candidly against the shoulder movement (which would normally press the neck to a forward slant); and so the silhouette is kept self-contained and the figure keeps its dignity. Notice, too, the neck in the reclining position of the Faun. Another poignant duplicity of emotion is expressed by the head, neck, and shoulder line of the *Jeux* photographs—the neck rising against lifted shoulders and also bent sideways against a countertilt of the head. The hero in *Jeux* seems to meet pathos with human nobility—not as the Faun does, with animal dignity.

Looking at these photographs farther along the figure, at the arms in particular, one is struck by their lightness, by the way in which they seem to be suspended in space. Especially in the pictures from *Pavillon* and from *Spectre*, they are not so much placed correctly, or advantageously, or illustratively; rather they seem to flow out unconsciously from the moving trunk, a part of the fullness of its intention. They are pivoted, not lifted, from the shoulder or shoulder blade; their force—like the neck's—comes from the full strength of the back. And so they lead the eye more strongly back to the trunk than out beyond their reach into space. Even when they point, one is conscious of the force pointing quite as much as the object pointed at. To make a grammatical metaphor,

the relation of subject to object is kept clear. This is not so simple in movement as a layman might think. A similar clarification of subject and object struck me in the bullfighting of Belmonte. His own body was constantly the subject of his motions, the bull the object. With other fighters, one often had the impression that not they personally but their cloth was the subject that determined a fight. As a cloth is a dead thing, it can only be decorative, and the bull edged into the position of the subject; and the distinctness of the torero's drama was blurred. Nijinsky gives an effect in his arm gesture of himself remaining at the center of space, a strength of voluntary limitation related, in a way, to that of Spanish dance gesture. (This is what makes a dancer's arms look like a man's instead of a boy's.)

An actual "object" to a dancer's "subject" is his partner. In dancing with a partner there is a difference between self-effacement and courtesy. Nijinsky in his pictures is a model of courtesy. The firmness of support he gives his partner is complete. He stands straight enough for two. His expression toward her is intense—in *Giselle* it expresses a supernatural relation, in *Pavillon* one of admiration, in *Faun* one of desire, in *Spectre* one of tenderness—and what a supporting arm that is in *Spectre*, as long and as strong as two. But he observes as well an exact personal remoteness, he shows clearly the fact they are separate bodies. He makes a drama of their nearness in space. And in his own choreography—in *Faun*—the space between the figures becomes a firm body of air, a

lucid statement of relationship, in the way intervening space does in the modern academy of Cezanne, Seurat, and Picasso.

One is struck by the massiveness of his arms. This quality also leads the eye back to the trunk, as in a Michelangelo figure. But it further gives to their graceful poses an amplitude of strength that keeps them from looking innocuous or decorative. In particular in the Narcissus pose the savage force of the arms and legs makes credible that the hero's narcissism was not vanity, but an instinct that killed him, like an act of God. In the case of *Spectre*, the power of the arms makes their tendril-like bendings as natural as curvings are in a powerful world of young desire, while weaker and more charming arms might suggest an effeminate or saccharine coyness. There is indeed nothing effeminate in these gestures; there is far too much force in them.

It is interesting to try oneself to assume the poses in the pictures, beginning with arms, shoulders, neck, and head. The flowing line they have is deceptive. It is an unbelievable strain to hold them. The plastic relationships turn out to be extremely complex. As the painter de Kooning, who knows the photographs well and many of whose ideas I am using in these notes, remarked: Nijinsky does just the opposite of what the body would naturally do. The plastic sense is similar to that of Michelangelo and Raphael. One might say that the grace of them is not derived from avoiding strain, as a layman might think, but from the heightened intelligibility of the

plastic relationships. It is an instinct for countermovement so rich and so fully expressed, it is unique, though the plastic theory of countermovement is inherent in ballet technique.

Nijinsky's plastic vitality animates the poses derived from dances by Petipa or Fokine. It shines out, too, if one compares his pictures with those of other dancers in the same parts. This aspect of his genius appears to me one basis for his choreographic style, which specifies sharply plastic effects in dancing—and which in this sense is related both to Isadora and to the moderns. Unfortunately the dancers who now take the role of the Faun do not have sufficient plastic discipline to make clear the intentions of the dance.

From the photographs one can see that the present dancers of *Faun* have not even learned Nijinsky's stance. Nijinsky not only squares his shoulders far less, but also frequently not at all. He does not pull in his stomach and lift his thorax. Neither in shoulders nor chest does he exhibit his figure. His stomach has more expression than his chest. In fact, looking at his trunk, one notices a similar tendency to flat-chestedness (I mean in the stance, not in the anatomy) in all the pictures. It is, I believe, a Petersburg trait, and shared independently by Isadora and Martha Graham. In these photographs, at any rate, the expression does not come from the chest; it comes from below the chest and flows up through it from below. The thorax, so to speak passively, is not only pulled at the top up and back; at the bottom and from the side

it is also pulled down and back. Its physical function is that of completing the circuit of muscles that holds the pelvis in relation to the spine. And it is this relation that gives the dancer his balance. Balance (or aplomb, in ballet) is the crux of technique. If you want to see how good a dancer is, look at his stomach. If he is sure of himself there, if he is so strong there that he can present himself frankly, he (or she) can begin to dance expressively. (I say stomach because the stomach usually faces the audience; one might say waist, groin, or pelvic region.)

In looking at Nijinsky pictures, one is struck by the upright tautness about the hips. His waist is broad and powerful. You can see it clearly in the Harlequin pictures. If he is posing on one leg, there is no sense of shifted weight, and as little if he seems to be bending to the side or forward. The effort this means may be compared to lifting a table by one leg and keeping the top horizontal. The center of gravity in the table, and similarly that of his body, has not been shifted. The delicacy with which he cantilevers the weight actually displaced keeps the firmness from being rigidity. I think it is in looking at his waist that one can see best the technical aspects of his instinct for concentrating the origin of movement so that all of it relates to a clear center which is not altered. He keeps the multiplicity, the diffusion which movement has, intelligible by not allowing any doubt as to where the center is. When he moves he does not blur the center of weight in his body; one feels it as clearly as if he were still standing at rest; one can follow its course clearly as

it floats about the stage through the dance. And so the motion he makes looks controlled and voluntary and reliable. I imagine it is this constant sense of balance that gave his dancing the unbroken continuity and flow through all the steps and leaps and rests from beginning to end that critics marveled at.

Incidentally, their remarks of this kind also point to an extraordinary accuracy in his musical timing. For to make the continuity rhythmic as he did, he must have had an unerring instinct at which moment to attack a movement, so that the entire sequence of it would flow as continuously and transform itself into the next motion as securely as did the accompanying sound. To speak of him as unmusical, with no sense of rhythm, as Stravinsky has, is therefore an impropriety that is due to a confusion of meaning in the word "rhythm." The choreography of *Faun* proves that Nijinsky's natural musical intelligence was of the highest order. For this was the first ballet choreography set clearly not to the measures and periods, but to the expressive flow of the music, to its musical sense. You need only compare *Faun*'s assurance in this respect to the awkwardness musically of Fokine's second scene in *Petrouchka*, the score of which invites the same sort of understanding. But this is not in the photographs.

Nijinsky does not dance from his feet; he dances from his pelvis. The legs do not show off. They have no ornamental pose. Even in his own choreography, though the leg gestures are "composed," they are not treated

as pictorial possibilities. They retain their weight. They tell where the body goes and how. But they don't lead it. They are, however, completely expressive in this role; and the thighs in the *Spectre* picture with Karsavina are as full of tenderness as another dancer's face. It is noticeable, too, that Nijinsky's legs are not especially turned out, and a similar moderate en dehors seems to be the rule in the Petersburg male dancers of Nijinsky's generation. But the parallel feet in *Narcisse* and *Faun* and the pigeon toes in *Tyl* are not a willful contradiction of the academic principle for the sake of something new. They can, it seems to me, be properly understood only by a turned-out dancer, as Nijinsky himself clearly was. For the strain of keeping the pelvis in the position the ballet dancer holds it in for balance is much greater with parallel or turned-in feet (which contradicts the outward twist of the thigh); and this strain gives a new plastic dimension to the legs and feet, if it is carried through as forcefully as Nijinsky does. I am interested, too, to notice that in standing Nijinsky does not press his weight mostly on the ball of the big toe, but grips the floor with the entire surface of the foot.

I have neglected to mention the hands, which are alive and simple, with more expression placed in the wrist than in the fingers. They are not at all "Italian," and are full of variety without an emphasis on sensitivity. The hands in *Spectre* are celebrated, and remind one of the hands in Picassos ten years later. I am also very moved by the uplifted, half-unclenched hands in the *Jeux* picture,

as mysterious as breathing in sleep. One can see, too, that in *Petrouchka* the hands are black-mittened, not white-mittened as now; the new costume makes the dance against the black wall in the second scene a foolish hand dance, instead of a dance of a whole figure, as intended.

The manner in which Nijinsky's face changes from role to role is immediately striking. It is enhanced by makeup, but not created by it. In fact, a friend pointed out that the only role in which one recognizes Nijinsky's civilian face is that of Petrouchka, where he is most heavily made up. There is no mystery about such transformability. People don't usually realize how much any face changes in the course of a day, and how often it is unrecognizable for an instant or two. Nijinsky seems to have controlled the variability a face has. The same metamorphosis is obvious in his body. The Specter, for instance, has no age or sex, the Faun is adolescent, the hero of *Jeux* has a body full-grown and experienced. Tyl can be either boy or man. The Slave in *Schéhérazade* is fat, the Specter is thin. It does not look like the same body. One can say that in this sense there is no exhibitionism in Nijinsky's photographs. He is never showing you himself, or an interpretation of himself. He is never vain of what he is showing you. The audience does not see him as a professional dancer, or as a professional charmer. He disappears completely, and instead there is an imaginary being in his place. Like a classic artist, he remains detached, unseen, unmoved, uninterested. Looking at him, one is in an imaginary world, entire and very clear;

and one's emotions are not directed at their material objects, but at their imaginary satisfactions. As he said himself, he danced with love.

To sum up, Nijinsky in his photographs shows us the style of a classic artist. The emotion he projects, the character he projects, is not communicated as his own, but as one that exists independently of himself, in the objective world. Similarly his plastic sense suggests neither a private yearning into an infinity of space nor a private shutting out of surrounding relationships, both of them legitimate romantic attitudes. The weight he gives his own body, the center which he gives his plastic motions, strikes a balance with the urge and rapidity of leaps and displacements. It strikes a balance between the role he dances and the roles of his partners. The distinction of place makes the space look real, the distinction of persons makes the drama real. And for the sake of this clarification he characterizes (or mimes, one might say) even such a conventional ornamental show-off, or "pure dance," part as that in *Pavillon*. On the other hand, the awkward heaviness that *Faun*, *Sacre*, and *Jeux* exhibited, and that was emphasized by their angular precision, was not, I believe, an anticlassic innovation. It was an effort to make the dance more positive, to make clearer still the center of gravity of a movement, so that its extent, its force, its direction, its elevation can be appreciated not incidentally merely, but integrally as drama. He not only extended the plastic range in dancing, but clarified it. And this is the way to give meaning to dancing—

not secondhand literary meaning, but direct meaning. Nijinsky's latest intentions of "circular movement" and the improvisational quality *Tyl* seems to have had are probably a normal development of his sense of motion in relation to a point of repose—a motion that grew more animated and diverse as his instinct became more exercised. (An evolution not wholly dissimilar can be followed in Miss Graham's work, for instance.) And I consider the following remark he made to be indicative of the direction of his instinct: "La grâce, le charme, le joli sont rangés tout autour du point central qu'est le beau. C'est pour le beau que je travaille" ("The graceful, the charming, the attractive are all arranged around a central point, which is the beautiful. It is for the beautiful that I strive"). I do not see anything in these pictures that would lead one to suppose that Nijinsky's subsequent insanity cast any premonitory shadow on his phenomenally luminous dance intelligence.

In their stillness Nijinsky's pictures have more vitality than the dances they remind us of as we now see them on the stage. They remain to show us what dancing can be, and what the spectator and the dancer each aspire to, and hold to be a fair standard of art. I think they give the discouraged dance lover faith in dancing as a serious human activity. As Mr. Van Vechten wrote after seeing him in 1916: "His dancing has the unbroken quality of music, the balance of great painting, the meaning of fine literature, and the emotion inherent in all these arts."

Dance Index, March 1943

A Ballet Lover's View of Martha Graham

Any one of Martha Graham's highly intelligent pieces would gain in theatrical brilliancy if she and her company could present it singly, say, as an item on a Ballet Theatre program. Her particular genius would flash more strikingly right next to the genius of other choreographers and dancers who excel at other aspects of dancing. Some of my friends are shocked by this genius of hers and they tell me she has no style, that she fascinates merely as heretics do, by her contrariness. But I keep being struck in all her work by its intellectual seriousness, its inventiveness, and its exact workmanship; and these are qualities I can't think of as heretical or contrary. They offer a moral basis for style. I see no reason why one shouldn't try to place her work in relation to the ballet tradition and see what is special in her dance method.

The special thing about Miss Graham is not that she is a modernist. Almost no one nowadays is anything else. Modernism in dancing is really a conservative tendency. Its first victories through Isadora and Fokine, its boldest ones through Nijinsky and Mary Wigman, its general acceptance in the twenties—these are facts of history. Inside and outside of ballet, modernism has emphasized the interest in bit-by-bit gesture, gesture deformed, interrupted, or explosive. It has done everything possible to break up the easy-flowing sequence of a dance.

But through all these modernisms well-trained ballet dancers made any gesture, however odd, with reference

to their traditional center of motion, and so still gave to a series of disjointed gestures a logical dance continuity. And through all these modernisms, too, ballet retained its traditional formula of the architecture of a piece, with the long dance aria (like the central adagio in *Swan Lake*) as the basic type of an expressive climax. Ballet dancers had sound models for dance coherence and for dance rhythm all around them.

The modern-school dancers, however, had no models for long, serious poetic forms: for them the fundamental questions of dance rhythm and dance continuity could not be referred to a traditional type. Miss Graham, for instance, began with the decorative attitudes and the connecting walks of Denishawn "exotica"; her formal point of departure was an actor's loose gesture sequence, not a dancer's logically sustained dance sequence. But against this enormous handicap she did succeed in discovering for herself a sound basis on which any sequence of gesture can keep a strictly logical continuity.

She has done this, I think, by developing an acute sense of the downward pull of gravity and of balance, and an acute sense, too, of where the center of pressure of a gesture is. By concentrating motion on these two elements, she can exaggerate or deform a gesture as far as she chooses without blurring it, and she can retract or transform a gesture without breaking the continuity of movement. She is the only one of our modern dancers who has really solved this fundamental problem in all its aspects.

Ballet began, one might say, on the basis of lightness, elevation, and ease; it could add modernism (which was an increased heaviness and an oddity of gesture) for its value as contrast. Miss Graham, beginning with modernism, made of heaviness and oddity a complete system of her own. Brilliancy in heaviness and oddity became her expressive idiom. This is one way of explaining why much of her style looks like ballet intentionally done against the grain, or why she has used lightness and ease not as fundamental elements but for their value as contrast. But Miss Graham's system keeps expanding, and this season her entire company now and again seemed to be using nonmodernist dance qualities not merely for contrast but directly.

Judged by what I look for in ballet, Miss Graham's gesture lacks a way of opening up completely, and her use of dance rhythm seems to me fragmentary. It does not rise in a long, sustained line and come to a conclusion. I find she uses the stage space the way the realistic theater does, as an accidental segment of a place, not the way the poetic theater uses the stage, as a space complete in itself. And I do not feel the advantage to dancing in these qualities of her style. But I am intensely curious to see what her next works will look like, and where the next ten years will lead her. I find watching her not a balm for the spirit, but certainly a very great pleasure for the intelligence.

New York Herald Tribune, May 28, 1944

Balanchine's *Apollon*; American Ballet Caravan

Now that the Metropolitan does have a ballet master-piece in its repertory—one as good as the very best of the Monte Carlo—there's a conspiracy of silence about it. It's true people ignored this ballet last year, too, when it came out, but I think they'd better go again, because they are likely to enjoy it very much. It's the Stravinsky-Balanchine *Apollon* I mean, which the Metropolitan is repeating this year, and which it does very well, even to playing the music beautifully.

It is a ballet worth seeing several times because it is as full of touching detail as a Walt Disney, and you see new things each time. Did you see the way Balanchine shows you how strangely tall a dancer is? She enters crouching and doesn't rise till she is well past the terrifically high wings; then she stands up erect, and just standing still and tall becomes a wonderful thing. Did you see how touching it can be to hold a ballerina's extended foot? The three Muses kneel on one knee and each stretches her other foot up, till Apollo comes and gathers the three of them in his supporting hand. Did you notice how he teaches them, turning, holding them by moments to bring each as far as the furthest possible and most surprising beauty? And it isn't for his sake or hers, to show off or be attractive, but only for the sake of that extreme human possibility of balance, with a faith in it as impersonal and touching as a mathematician's faith in an extreme of human reasoning. And did you notice the

countermovement, the keenness of suspense, within the clear onward line of Terpsichore's variation (what the moderns call the spatial multiplicity of stresses)? The intention of it—the sense of this dance—is specified by a couplet quoted in the program, a couplet by Boileau which contrives to associate the violence of cutting, hanging, and pointing with an opposite of rest and law, and makes perfect sense, too:

> Que toujours dans vos vers le sens coupant les mots,
> Suspende l'hemistiche et marque le repos.

> [Let meaning in your verse that shapes each word,
> Always halve the line so that a rest is heard.[1]]

Aren't you curious to see how incredibly beautiful this couplet is when danced? Or did you notice how at the end of a dance Balanchine will—instead of underlining it with a pose directly derived from it—introduce a strange and yet simple surprise (an unexpected entrance, a resolution of the grouping into two plain rows), with the result that instead of saying, "See what I did," it seems as though the dancers said, "There are many more wonders, too." And did you notice how much meaning—not literary meaning but plastic meaning—he gets out of any two or more dancers who do anything together? It's as though they were extraordinarily sensitive to each other's presence, each to the momentary physical strain of the other, and ready with an answering continuation,

so that they stay in each other's world, so to speak, like people who can understand each other, who can belong together. And he combines this intimacy with an astonishing subtlety on the part of each individually. The effect of the whole is like that of a play, a kind of play that exists in terms of dancing; anyway, go and see if you don't think it's a wonderful ballet. The subject is the same as that of the music, which as you know is "the reality of art at every moment."

The dancers at the Metropolitan do these extremely difficult dances very well. Lew Christensen (from the Caravan) has, it is true, a personal style that is easy rather than subtle; but, besides being an excellent dancer, he is never a fake and at all times pleasant. The girls have a little more of the Balanchine tautness and they, too, are excellent dancers and appealing. The costumes are good.

The intelligentsia turned out in full for the All-American Evening of Kirstein's American Ballet Caravan; they approved the whole thing vociferously, and they were quite right. There was a happy community feeling about the occasion, a sort of church-social delight, that would have surprised the out-of-towners who feel New York is just a big cold selfish place, where nobody has any interest in anybody else. The ballets—*Show Piece* by McBride and Hawkins, *Yankee Clipper* by Bowles and Loring, and *Filling Station* by Thomson and Christensen—taken together show that an American kind of ballet is growing

up, different from the nervous Franco-Russian style. From Balanchine it has learned plasticity, and openness, and I imagine his teaching has fostered sincerity in these dancers as in others he has taught. But our own ballet has an easier, simpler character, a kind of American straightforwardness, that is thoroughly agreeable. None of these ballets is imitative or artificial, and there is nothing pretentious about them. Hawkins shows us a good-humored inventiveness, Loring a warmth of characterization, and Christensen a clear logic of movement that are each a personal and also specifically American version of ballet. I think this is the highest kind of praise, because it shows the ballet has taken root and is from now on a part of our life. And the dancers themselves have an unspoiled, American, rather athletic quality of movement that is pleasant. As a group they are first-rate in their legs and feet and in the profile of the arms. I think they still lack an incisive stopping, and the expressiveness across the shoulders that will shed light through the correctness of movement; but their improvement in the last two years has been so phenomenal that these reservations aren't serious. At present the boys steal the show, especially Christensen, with his great ease, and Loring, with his human quality, but they don't try to steal it; and Albia Cavan and Marie-Jeanne show they intend to catch up with them. But one of the very good things about the Caravan is its homogeneity as a group. And I congratulate them all wholeheartedly, just as the audience did.

Of Balanchine's ballet in the *Goldwyn Follies* I would like to say that it is worth seeing if you can stand the boredom of the film as a whole (but don't leave before the mermaid number of the Ritz Brothers). It is worth seeing because the dancing is good, and one can see it; and because there's something moving left about the piece as a whole. But it is particularly interesting because you see a number of dance phrases that were composed into the camera field—an effective and necessary innovation anyone could have learned from Disney, but which nobody tried till now. It is the only way dancing can make sense in the movies.

Modern Music, March–April 1938

1 Translation by Richard Howard.

Kurt Jooss

Jooss's works one looks at very seriously. They are on the plane of "masterworks." Jooss has a great reputation, too, as a leader in serious theater dancing and as a systematizer of modern technique. Just the same, watching the stage, what I saw was one dud after another. There is one exception—the famous first scene of his *Green Table*. This is brilliant and curiously different from all the rest: different in rhythm, style, humor, and theatrical punch.

The Jooss dancers are engaging, accurate, lively, and devoted executants, without mannerisms or bad manners, dancers by nature. They were fine for Miss de Mille. But when they dance the Jooss choreography, what do you see them do on the stage? Well, the best thing you see is a controlled, clear, wide movement in the arms. (And they can stop an arm gesture more neatly than most good dancers.) Their hands and necks are plain and good. The breastbone is held high and the chest is open. This upper third of the body is excellent. But below it, the belly is dull, the buttocks heavy, the small of the back sags in. Where is the shining tautness across the groin, a glory of Western dancing? These people might as well be sitting down, as far as the expressiveness of their middle goes. And below, the leg gestures are forced and heavy. The leaps are high and strong, but they have only bounce, they don't soar (except one boy in *Old Vienna*); they don't hang in the air either. (The

low wide leaps are the interesting ones but get monotonous.) The feet in the air look thick. On the other hand these dancers land better from a leap than most ballet dancers. Does this add up to a satisfactory new norm of technique? It does not. Neither does it exhaust the possibilities of the modern school. Because the Jooss norm of the outward chest and inward middle is fixed, and modern technique demands that any portion can vary at will from outward to inward. It's a terrific demand, but it's the essence of widening the expressive range beyond that of classic ballet.

Or take the Jooss stylization of rhythm. I see an emphatic pound (this is, a gesture stopped and held). Then comes an unaccented moment (no gesture, change of position). Then comes another equally emphatic pound (a new gesture, stopped and held). This keeps up all evening. In the pit the music pounds down on the beat at the same moment the dancer pounds out his gesture. The effect is very dispiriting.

What happens is that there is a systematic alternation between emphatic and unemphatic movement, like that between beat and nonbeat in a bar. There is also an unusual continuousness about the time quality of the movement. Many people are dissatisfied with a kind of hoppitiness in classic ballet. They point out that there is a fraction of a second between steps, between arm positions, that goes dead in the way a harpsichord goes dead, but not an orchestra, or even a piano. Jooss has stretched a movement to fill the time space completely; he uses a

pedal. It was Dalcroze who thirty years ago made us most conscious of this possibility in moving.

When a dancer makes his gesture coincide as closely as possible with the time length and time emphasis of musical rhythm, he is apt to be as pleased as a hen is who has laid an egg. He tells everybody, "Look how musical I am," and everybody cackles back, "Isn't he just the most musical thing!" Rationally it seems odd to confuse the metrics of music with musicality. And also to assume that the metrics of dancing are identical with those of music. It strikes me that there is in fact an inherent disparity. The proportioning of time, as well as the proportioning of emphasis, between the stress and the follow-through of a single metric unit is much more regular in music than it is in movement. Apart from theory, in practice this kind of measured gesture draws attention to itself and away from the body as a whole. In practice, too, the dancer loses a certain surprise of attack, which is one of his characteristic rhythmic possibilities.

Well, in point of musicality, listen to the music Jooss uses. True, the dancers obey the metrics of music, but the music in its rhythmic development obeys beat by beat the rhythmic detail of the dance. The piece makes no musical sense. It is merely a cue sheet for the dancers. It sounds as if it kept up a continuous gabble about the mechanics of the steps. It's like a spoken commentary in a documentary film that names every object we see while we're looking at it. Music that can't make any

decision on its own is functioning on a bare subsistence level, and it is apt to be as glum as that. Poor Frederic Cohen's voluble cue-sheets for Jooss are utterly depressing; they remind me most of cafeteria soup gone sour. I don't think much of the musicality of a director who makes me listen to such poverty. If this is collaboration, it must be the Berlin-Vichy kind. I detest a dancer who is satisfied with it.

I don't go to the theater to see a servant problem solved. Jooss of course isn't the only choreographer who has music in to do the dirty work and keeps all the dignity for himself. Modern dancers have made the same error often enough in the past. They commission a new composer, but when the piece is played it has (like a poet's advertising copy) no character, it only has manner. For a while it was fun enough to listen to a new manner, and affix at least an ideological, a historical meaning. But the historical significance of style is a parlor game that gets tiresome. I wish all kinds of dancers would let us hear pieces of music old and new, and do, while they are played, whatever they like to. I wish they would put themselves on the spot in the presence of serious music. When the dancer acts serious and the music is trivial, he can't escape seeming petty and provincial. Anyway, in the theater I want the dancer to dance, the orchestra to make music, and the décor to be a stage picture. If these three don't come out in accord, I am angry but still interested. If only one of them is allowed to speak up, the production isn't big time.

But the issue of dance music has led me away from the subject of Jooss. Besides technique, rhythm, and the use of music, there are many other aspects to choreography. In the Jooss ballets I did not see any I cared for. He has systematized grouping so that diagonals, cubes, and spheres cut across each other by the dozen. But they look stupid because they have no relation to the size of the human figure on the stage. He has systematized the representational aspect of movement, with the result that every gesture can be translated so exactly into words, the dance might as well be a series of signals for deaf mutes. You imagine it would have the same meaning if performed by nondancers. The dancers add neatness, but they don't by dancing create the meaning, a meaning which undanced would not exist. Looking at it another way, all the gesture is on the same level of signification. The wonderful shift possible from pantomime to lyric (like a new dimension of spirit), or the shift as in Spanish dancing from standing around to taking the stage—all this, with all the rest in dancing that is tender and variable and real only the moment it happens, has been systematized away.

A systematization of modern dancing, like the literary adoption of the heroic couplet, makes a great deal of sense to dancers floundering between the arrogant academicism of the ballet on the one hand and the uncompromising private language of some studio dancers on the other. I remember fourteen years ago in Germany the attempt to establish a new academy, a new order,

seemed of the greatest importance, and we all watched Jooss's gradual discoveries (for he was the leader of the movement) with delight. The results shown here this fall are well worth acrimonious theoretical dispute. But what I actually looked at on the stage was a stodgy, self-satisfied, and petty solemnity, pretending to be serious and, worse, significantly ethical.

Modern Music, November–December 1941

Elegy – the Streets

Si bien que si quelcun me trouvait au bocage
Voyant mon poil rebours et l'horreur de mon front
Ne me dirait pas homme mais un monstre sauvage.
—Ronsard

You streets I take to pass some time of day
Or nighttime in the neutral open air!
Times when the rented room for which I pay
As if it could resent my mind's despair
Becomes like a trained nurse's torpid stare
Watching dead-eyed her feeble patient's malice—
When white walls feel like that, I leave the house.

Then, as dead poets did to ease their pain,
The pang of conscious love that gripes the chest,
As those men wandered to a wood grown green
And seeing a day turn grew less depressed—
Who long are dead and their woods too are dead—
Like them I walk, but now walk streets instead.

The public streets, like built canals of air
Where gracefully the foul-mouthed minors run
And fur-faced pets crouch at the side and stare
Till this one afternoon's one turn is done,
And animals and children disappear.
But all night the laid pavements remain bare.

Streets, with insistent buildings forced in blocks
Reverberating the work-morning noise,
With foolish taxis, heavy painted trucks,
Close-stepping girls and blankly confident boys,
With stubborn housewives and men of affairs
Whose self-importance looks jerky out of doors.

They pass in droves, detouring packing cases,
They press up close at crossings, dart at cars,
Some stop, some change direction, and their faces
Display unconsciousness, like movie stars.
The rage that kicked me howling in my room,
The anguish in the news-sheet, is here a dream.

The lunch-hour crowd between glittering glass and signs
Calmly displays the fact of passing time:
How the weight changes, now swells now declines,
Carried about for years beyond our prime.
My eyes—like a blind man's hand by pressure—learn
The push of age in the crowd's unconcern.

As comfortable as the day's pleasant thrust
That shifts the lunch-hour into afternoon,
So years shift each appearance people trust,
Deforming in detail—yet all, how soon!
The same years that in full view new create
Boys' agile backs, girls' easy-sided gait.

People pour past me in the summer blaze.
Each nose juts out, flat red tragic or high
Like a grove's leaves standing in different ways,
None like a monster occupies the sky;
My feature too that all my secrets sees
Stands here another nose, as used as these.

But in the night, in an avenue's immenseness
Emptied by winter wind and bestial sleep,
I like a dog alone then scan defenseless
The girder-trussed constructions near which I creep.
Dead as the limits of a person's fate,
As time one man can own, they isolate.

For property is private during night.
The passerby who glances up its floors
Pulls back his eye, meek as a hypocrite.
Up soars the facing wall, and up soars spite.
So fame impends, that mummifies and stores.
The fears a man has by himself are grand
Who peers about him where the buildings stand.

Grandeur that fakes the scale of my displeasure,
I who, one citizen, came for a stroll.
The fool who hates himself is not my measure:
I like the shell of streets in the cold's hole,
But not by pardon is my grief appeased,
By no humiliation, I, released.

This city and the piece between of heaven,
The stars in blackness on all the Atlantic Shelf,
It is the horrid birthright by birth given
For me to look at, who never views himself.
I watch in solitude the death of others
That splits my mind as children tear their mothers.

March moonlight wonders at this punishment.
The shine is mild and distances, unknown;
Flatly on cornices is the light spent;
The sky draws my eyes up, it dwarfs the scene.
I feel no need of hope that later ends;
I hate how rare it is to stay near friends.

So seasons alter the streetscape where I walk,
Illuminations its painted color use,
I stop for coffee, most persons like to talk,
They and I also long surviving news.
Interest awhile like weather will disperse,
I go back to my room and tie it down in verse.

A sound of measured language in the ears
In time, in place, wherever men inhabit,
Familiar tone within three thousand years
Verse is a civilized, a friendly habit.
Nature and money thrust us close, and sunder;
Verse makes less noise and is a human wonder.

Five Reflections

 1.

Hung Sundays from Manhattan by the spacious
59th Street Bridge are the clear afternoons
In Astoria and other open places
Further in the enormous borough of Queens.

Thickly settled plain an ocean climate cleans
Rail and concrete, asphalt and weed oasis,
Remote Queens constructs like desert-landscape scenes
Vacant sky, vacant lots, a few Sunday faces.

In this backyard of exploitation and refuse
Chance vistas, weights in the air part and compose—
Curbs, a cloud, metropolitan bulks for use
Caught off guard distend and balance and repose.

So New York photographed without distortions
Show we walk among noble proportions.

2.

Meeting a freightyard head-on, the wide street
Heaves its surfacing on steel, takes to the air
Handsomely ponderous, expensively neat
Crosses the property and descends with care.

Along the sidings plants stand white and square
A rooftank on their innocent concrete
Like a pod; steel-filigree masts, sunk and spare,
Power high across the track-area secrete.

These utilities, clear as a toothbrush
And whose unmoveableness terrify
Suspended here in a photograph's hush
Contact and reciprocate the spread of the sky.

Even like a modest look on a large face
See the bolted lattice-work have almost grace.

3.

On weedy outskirts the factories lodge
As casually as tents that nomads dispose—
A few men loafing in front of a garage
Have a look like it of uncommitted repose.

And so despite the divergent windowrows
Concrete flatness and its white resplendent edge
The eye looks for how the ground's undulation goes
Undomiciled, taking the sky for a gauge.

Evasive looking, coexisting with police
With deeds and contracts, with paychecks and bills—
These are the views a heart finds to beat in peace,
Like the country of years it once only fills.

The eyes play with the luck their limits contain
Caressing a slender lamp-post, a squat sedan.

4.

You can have the measurements O.K.ed, mailed,
Talk with the bank, and get the building faced,
Carry it on the books, and when the firm's failed
Pedestrians still go by the slabs as placed.

Pride shifts from this accomplishment to that,
Leaves old killings and half a city built,
The noise that smoothed it like a swimmer's fat
Disintegrates into Sunday bits of dirt.

Measurements however in straight angles to
The pavement and a standpipe do not so move,
As if the mind shifts slower than people do
And keeps widening the space between love and no love.
This widening like a history mystery
Is what Rudy's camera takes in the city.

5.

An eye is wide and open like a day
And makes a sign in an American field,
The field of lettering, which reaches each way
Out to the section-line and does not yield,
Stops simply at that imaginary line
That begins a like life in a like square,
A neighbor's other name and other sign,
From here (like) you can see Ray's silo over there.

Rudy like Sherlock with a microscope
Finds this field under our nose outside the heart,
But says he wasn't thinking of farms, the dope,
Nor of the charm of the inscription part.

(In the mind, though, this enormous intersection
Moves about like in water a reflection.)

To peer at the common man as at a hero
Is an error like addressing Hitler, Hey Mack,
As a man of the world your rating would be zero,
All you get from Mack is a view of his back.

Believe it or not, this city is common
To people who are historically unsuccessful,
Any day anyone is no other than someone,
A woman can be particular and a man full.

Some place any one is someone anyday,
Which Rudy proves here clearly out of Euclid,
Or any one is no other than someplace anyway—
Leaving a dictator as an historic nucleus,
Someone today is anyone in the same place,
Not to his family, but like considered in space.

Rudy Burckhardt, photographs from *New York, N. Why?*, an album with poems by Edwin Denby, c. 1939. Gelatin silver prints

A Note to Composers

A composer unfamiliar with the theater who is interested in writing ballets should certainly see the big companies as often as possible and watch what happens. I think he should start by watching *Sylphides* or *Carnaval* (now in the Monte Carlo repertory), because both are obvious and successful; the relation of dance steps to music in both ballets is blunt but bold. If he watches the dancers and listens to the music at the same time, he will see how the visual rhythm frequently goes against the acoustic one. He can see how the choreographer runs over the end of a phrase, distributes effects and accents sometimes with, sometimes against the pattern of the music. Look at the group accents in the final measures of most of the *Sylphides* numbers; or at the way in the Schumann the same motive is danced with different steps, or the rhetoric of a piece is broken into by different entrances.

If he looks more closely he will see how a dance phrase rests on several accents or climaxes of movement which other movements have led up to or from which they will follow, as unaccented syllables in speech surround an accented one. He will see that the dance accents frequently do not reproduce the accents of a musical phrase, and that even when they correspond, their time length is rarely identical with musical time units. (A leap for instance that fills two counts may end a shade before, and the next movement begin a shade after the third count.) The variations of energy in dancing around which a

dance phrase is built are what make the dance interesting and alive; and they correspond to a muscular sense, not to an auditory one. I think it is the fact that in ballet technique these instants of emphasis are not expected to be identical with the metrical values, but increases or decreases in a time value of its own. (The beat and off-beat as the dancer executes them are differently long.)

Many musicians are bothered by noticing that dancers "can't keep time." I often notice how dancers who are keeping time become dull and unrhythmic. Keeping time at all costs destroys the instinctive variability of emphasis, it destroys the sense of breathing in dancing, the buoyancy and the rhythmic shape of a dance phrase. To be sure, an exaggerated rubato on the other hand looks loose; and it destroys the spring and force and cumulative sweep of the beat. In performances of music, musicians understand very well this problem of adjustment; dancing presents another form of it, made more complicated by the fact that the edge in accentuating a bodily gesture (which underlines its correspondence with the musical beat) is a device that rapidly becomes monotonous to the eye and that tends to dehumanize the look of a dancer onstage. A dancer onstage is not a musical instrument, she is—or he is—a character, a person. The excitement of watching a ballet is that two very different things—dancing and music—fit together, not mechanically but in spirit. The audience feels the pleasure of a happy marriage at least for the fifteen minutes the piece lasts.

Ballet music is conceived as music that is marriage-able—its inherent animation will not be destroyed by the physical presence of dancing or even by the unavoidable racket that dancing makes onstage, and its continuity will not collapse under the rugged conditions of theater presentation. The more delicately hermetic the composition, the more necessary it becomes to listen with absorption and the more necessary it becomes to play it in just one way. For dancing, however, the conductor has to see to it that dancers hear their cues and can meet the tempo—and even (as in opera) temperamental variations of tempo are inevitable with good dancers. So a composer is safer if he does not count on orchestral subtlety of emphasis in theater execution, which the poor quality of ballet orchestras, the lack of rehearsal time, the physical necessities of dancing, and the plan of the choreographer are each likely to endanger.

No one who watches a good ballet with attention can hear the score as distinctly as he would in concert. Once the curtain is up, the music functions in the show as a spiritual atmosphere for the stage action, as giving the general emotional energy of the piece, its honesty, cheerfulness, steadiness, or amplitude; with occasional bursts of danciness, of lyricism, of wit or rhetoric, and an effective conclusion which are more consciously heard. A composer cannot count on finding a choreographer as exceptionally musical as Balanchine. But he should count on finding a choreographer, a dance company, and an audience who respond to the inherent charac-

ter of his musical communication. He can count on an audience that appreciates perfectly well the largeness of imagination—if not the technical detail—of ballet scores like Tchaikovsky's or Stravinsky's, and responds to their imaginative scope with an eagerness rare in concert audiences.

Modern Music, October–November 1939

About Ballet Decoration

Because ballet dancers keep moving all over the stage and because in looking at them you keep looking at all the scenery all the time, ballet decoration is observed in a livelier way than play or opera decoration. In fact as a ballet unfolds and your interest in watching it grows, you become more susceptible to visual impressions and so more sensitive, too, to the decoration. In plays or opera you forget the scenery for long stretches while the performers stay still and you listen more and more captivated to their voices. The real dramatic power of a play or opera is felt to such an extent by listening that you can be thrilled even when you sit at the radio with no stage to watch at all. But the dramatic power of a ballet is in its visual impact. You feel it by seeing just how the dancers move, seeing their impetus in relation to each other and also their force in relation to the entire stage— how far they choose to go in contrast to how far they might go.

The force with which dancers approach, touch or separate, come forward toward you or retire, take possession of stage center or pause isolated near the wings, these changing intensities are meant to have a cumulative effect. You appreciate this best if you sit far enough back to view the whole stage at a glance, so that its height and width can act as a fixed frame of reference. Ballet scenery and costumes are meant to make the action of the dance distinctly visible at a distance and also to give

a clear coherence to its variety, a livelier common term to its action than the mere empty stage areas.

For this purpose a décor so busy that it confuses or so stuffy that it clogs the animation of the dances is no use. But it cannot be timid. It must have power enough to remain interesting and alive as the dancing gradually sharpens the visual susceptibility of the audience. One of our finest sets—Pierre Roy's *Coppélia*—does this without attracting any notice to itself at all. The effect of a décor is right when, as the ballet gathers momentum, the dancers seem to have enough air all around to dance easily; when you see their long dance phrases in clear relation to center stage; when the flats keep the force of the gesture from spilling aimlessly into the wings; then the dancers—no matter how odd they looked at first—can come to look natural in the fanciful things they do, the natural fauna of the bright make-believe world they move in.

The present standards for ballet decoration were set by Picasso, whose *Three-Cornered Hat* is still pictorially alive after twenty-five years. The reason easel painters are better designers for ballet than anyone else is that they are the only craftsmen professionally concerned with what keeps pictures alive for years on end. When they know their trade they make pictures that hold people's interest for hundreds of years; so making one that will be interesting to look at for twenty minutes is comparatively easy for them.

A ballet set has to stand up under steady scrutiny almost as an easel painting does. At first sight it tells a story,

it has local color or period interest or shock value. But then it starts to change the way a picture in a museum does as you look at it attentively for five or ten minutes. The shapes and colors, lines and textures in the set and costumes will act as they would in a picture, they will seem to push and pull, rise and fall, advance and retreat with or against their representational weight. The background may tie up with a costume so that the dancer's figure seems to belong in it like a native, or it may set him plainly forward where he has a floor to dance on. A good ballet décor, like a good painting, does different and opposite things decisively; like a painting, it presents a bold equilibrium of pictorial forces. And when the bold equilibrium in the décor corresponds in vitality to that of the dancing and that of the score, then the ballet as a production is alive and satisfactory.

The decorations by Picasso, Roy, Berman, and Chagall in our current repertory (Bérard's and Tchelitchew's are at the moment in storage) set a satisfactory standard—the highest in the world. It is a standard worth keeping because it is clearly a pleasure; worth keeping for the time when other native American easel painters join Oliver Smith in working for ballet, as despite management and union, they obviously should. Painters as they are, they will enjoy furnishing the pictorial power and nobility of presence ballet thrives on; and to see their American invention so openly presented would be a great pleasure to them and to us.

New York Herald Tribune, November 26, 1944

Laurel Hill

A desert is fine for engineering
You use it and shack up on top of it
New York that might have nestled endearing
Fixed itself a desert on which to sit.

At Laurel Hill, Greater New York City,
See the soil Fifth Avenue encases—
Ground for a mining camp, base for meaty
Three-year-olds with free, impervious faces.

See the chapel like a blueprint. A skyway
And a graveyard. The light is so clear it cuts.
Being Sunday, the truck is home for the day.
With a drink at the radio pa sits.

Far away is right here on a plain sky
Air anywhere to change, anywhere to die.

Villa Adriana

Who watched Antinous in the yellow water
Here where swollen plains gully, Roman and brown
Built for fun, before a flat horizon scattered
Fancies, such advanced ones, that lie overthrown;
Urbanely they still leer, his voided surprises
Curved reflections, double half-lights, coigns of rest
Embarrassing as a rich man without admirers
Peculiar like a middle-aged man undressed;
Over the view's silent groundswell floats a field
Enskied by one eerie undeviating wall
Far to a door; pointing up his quietude
Watchful Hadrian exudes a sour smell;
The ratty smell of spite, his wit, his laughter
Who watched Antinous smile in yellow water

Sant'Angelo d'Ischia

Wasps between my bare toes crawl and tickle; black
Sparkles sand on a white beach; ravines gape wide
Pastel-hued twist into a bare mountain's back
To boiling springs; emblems of earth's age are displayed;
At a distant end of beach white arcs piled
Windows, and in the sea a dead pyramid washed
As if in the whole world few people had survived
And man's sweetness had survived a grandeur
 extinguished;
Wonders of senility; I watch astonished
The old hermit poke with a stick the blond lame boy
Speaking obscenities, smiling weird and ravished
Who came from New York to die twenty years ago;
So at a wild farmer's cave we pour wine together
On a beach, four males in a brilliant weather

Florence

Delicious tongue that poisons as it kisses
Arno, that Dante guzzled sandy and hot
Licks streets glummer than New York's but possessing
Capacious idols dead magicians begot;
Graceful as the idols, glancing limbs and fingers
Swaying bellies thread the streets, liquidly proud
A kissing of observant flirts who tingle
Dangle like brass ornaments on a used bed;
Beyond the hospital, slopes of soft olives
A prospect of humped tower and of floated dome
Shapes in the confined landscape where August seethes
Wasting, present Tuscan violence untamed;
Alurk, the hillocks, a dwarfed peak, a shallow plain
Peasant like Arno, lie insidious in the blaze

Snoring in New York – an Elegy

When I come, who is here? voices were speaking
Voices had been speaking, lightly been mocking
As if in and out of me had been leaking
Three or four voices, falsely interlocking
And rising, one or two untruly falling
Here, who is here, screaming it or small calling

Let it call in the stinking stair going down
Mounting to a party, the topfloor ajar
Or later, a thick snowfall's silence begun
Crowded boys screaming shameless in a fast car
Laughing, their skulls bob backward as if weeping
These happy voices overhang my sleeping

I slide from under them and through a twilight
Peer at noon over noon-incandescent sand
The wild-grown roses offer warbling delight
Smell of dwarf oaks, stunted pines wafts from the land
The grin of boys, the selfcentered smile of girls
Shines to my admiring the way a wave curls

Or just their eyes, stepping in washed cotton clothes
Tight or sheer, rubber or voile, in the city
Hot wind fanning the cement, if no one knows
Noon-incandescent, the feel at their beauty
Stranger's glance fondling their fleshed legs, their
 fleshed breast
They enjoy it like in a pierglass undressed

And enjoy the summer subway bulge to bulge
The anonymous parts adhesive swaying
Massive as distortions that sleepers divulge
So in subterranean screeching, braying
Anaesthetizing roaring, over steel floors
Majestically inert, their languor flowers

And nude jump up joking alert to a date
Happy with the comb, the icebox, the car keys
How then if rings, remark or phone, it's too late
Fury, as unpersonal as a disease
Crushes graces, breaks faces, outside inside
Hirsute adults crying as fat babies cried

Covered over, lovered over and older
The utterance cracked and probing thievishly
Babyfied roving eye, secretive shoulder
The walk hoisted and drooped, exposed peevishly
The groom's, bride's either, reappears in careers
Looking fit, habitual my dears, all these years

So at the opening, the ball, the spot abroad
At the all-night diner, the teen-age drugstore
Neighborhood bar, amusement park, house of God
They meet, they gossip, associate some more
And then commute, drive off, walk out, disappear
I open my eyes in the night and am here

Close them, safe abed, hoping for a sound sleep
Beyond the frontier that persons cross deranged
Anyone asleep is a trustful soft heap
But so sleeping, waking can be interchanged
You submit to the advances of madness
Eyes open, eyes shut, in anguish, in gladness

Through the window in fragments hackies' speech
 drifts
Men, a whore, from the garage, Harlem and Queens
Call, dispute, leave, cabs finish, begin their shifts
Each throat's own pitch, fleshed, nervy or high, it leans
In my open ear, a New Yorker nearby
Moves off in the night as I motionless lie

Summer New York, friends tonight at cottages
I lie motionless, a single retired man
White-haired, ferrety, feminine, religious
I look like a priest, a detective, a con
Nervously I step among the city crowd
My private life of no interest and allowed

Brutality or invisibility
We have for one another and to ourselves
Gossamer-like lifts the transparent city
Its levitating and ephemeral shelves
So shining, so bridged, so demolished a woof
Towers and holes we sit in that gale put to proof

Home of my free choice; drunk boys stomp a man who
Stared, girls encompass a meal-ticket, hate fate
Like in a reformatory, what is true
To accept it is an act, avoid it, great
New Yorkers shack up, include, identify
Embrace me, familiarly smiling close-by

Opaque, large-faced, hairy, easy, unquiet
The undulant adolescents flow in, out
Pounce on a laugh, ownership, or a riot
The faces of the middle-aged, dropped or stout
But for unmotivatedness are like saints'
Hiding no gaps, admitting to all the taints

They all think they look good—variegated
As aged, colored, beat—an air unsupported
But accustomed, corpulent more than mated
Young or old selfconsciousness uncomforted
Throw their weight—that they each do—nowhere
 they know
Like a baseball game, excessively fast, slow

Mythically slow or slow United States
Slow not owned, slow mythically is like dearer
Two slowly come to hear, one indoors awaits
Mere fright at night, bright dismay by day, fear is
Nearer, merer and slower, fear is before
Always, dear always is, fear increases more

More civilization; I have friends and you
Funny of evil is its selfimportance
Civilization people make for fun; few
Are anxious for it; though evil is immense
The way it comes and goes makes jokes; about love
Everybody laughs, laughs that there is enough

So much imagination that it does hurt
Here it comes, the irresistible creature
That the selves circle until one day they squirt
It lifts sunset-like abysses of feature
Lifts me vertiginous, no place I can keep
Or remember, leaping out, falling asleep

A fall night, September, black, cold
Sheen on branches from lit windows
Thin fog; before sunset not a cloud
Surveyed the lake from its marsh end
Water, many leaves shone silver
A breeze blew, whitish brilliant sky
Dark hills, dark the landscape appeared
Minutely stereoscopic
Spongy dusk was more comforting
A door slammed, cooking, greasy pots
Night has me now, by itself from
Forever, go to bed a coward
Swum supine in brightness, raised my head
Immortal shone afloat in trunks

Heavy bus slows, New York my ride
Speeds up, on the hill Rudy waves
Then faster seize me, pivot, evade
A mien, step, store, lawn sliced from lives
A nap at dusk; entering night
Landscape threatens, no matter which
Caveman's faith, artificial light
A shack in the woods, the turned switch
One a.m. stop; drunk or sly strangers
Turnpike, the bus wheezes, slows, drives
And so Bronx, known Manhattan kerbs
Turned key in my lock, the door gives
Miserably weak, pour some shots
Don't look, make the bed, it's day out

Disorder, mental, strikes me; I
Slip from my pocket Dante to
Chance hit a word, a friend's reply
In this bar; bare, dark avenue
The lunge of headlights, then bare dark
Cross on red, two blocks home, old Sixth
The alive, the dead, answer, ask
Miracle consciousness I'm with
At home cat chirps, Norwegian sweater
Slumped in the bar, I mind Dante
As dawn enters the sunk city
Answer a one can understand
Actual events are obscure
Though the observers appear clear

The poet, dancer, and critic EDWIN DENBY (1903–1983) was born in Tianjin, China, and spent his childhood in Shanghai before moving to Vienna and later Detroit. Initially interested in psychoanalysis, he attended Harvard and the University of Vienna before studying modern dance at the Hellerau-Laxenburg School in Vienna. He performed as a company dancer for several years and returned to the United States in 1935. In 1936, Denby contributed articles to *Modern Music*, a journal for composers and musicians, where he also wrote on dance. In 1942 he took on the role of dance critic for the *New York Herald Tribune*, and he later contributed regularly to *Ballet* and *Dance Magazine*, among other journals. His writings on dance are compiled in *Looking at the Dance* (1949), *Dancers, Buildings, and People in the Streets* (1965), and *Dance Writings and Poetry* (1998). His poetry collections include *In Public, In Private* (1948), *Mediterranean Cities* (1956), *Snoring in New York* (1974), *Collected Poems* (1975), and *The Complete Poems* (1986).

CAL REVELY-CALDER is the literary editor of *The Telegraph*. His work has been published in *Artforum*, the *London Review of Books*, *The Nation*, and elsewhere. He has won awards for his criticism from *Frieze* and *The Guardian*.

THE *EKPHRASIS* SERIES

"Ekphrasis" is traditionally defined as the literary representation of a work of visual art. One of the oldest forms of writing, it originated in ancient Greece, where it referred to the practice and skill of presenting artworks through vivid, highly detailed accounts. Today, "ekphrasis" is more openly interpreted as one art form, whether it be writing, visual art, music, or film, that is used to describe another art form, in order to bring to an audience the experiential and visceral impact of the subject.

The *ekphrasis* series from David Zwirner Books is dedicated to publishing rare, out-of-print, and newly commissioned texts as accessible paperback volumes. It is part of David Zwirner Books's ongoing effort to publish new and surprising pieces of writing on visual culture.

OTHER TITLES IN THE *EKPHRASIS* SERIES

That Still Moment:
Poetry and Essays on Dance
Edwin Denby

Published by
David Zwirner Books
520 West 20th Street, 2nd Floor
New York, New York 10011
+ 1 212 727 2070
davidzwirnerbooks.com

Editor: Elizabeth Gordon
Editorial coordinator: Jessica
Palinski Hoos
Proofreader: Michael Ferut
Project intern: Camilla Keil

Design: Michael Dyer / Remake
Production manager: Luke Chase
Color separations: VeronaLibri,
Verona
Printing: VeronaLibri, Verona

Typeface: Arnhem
Paper: Holmen Book Cream, 80 gsm

The texts in this volume are
reprinted from Edwin Denby,
Dance Writings and Poetry,
ed. Robert Cornfield (1998);
Edwin Denby, *Dance Writings*,
ed. Robert Cornfield and William
MacKay (1986); and Edwin Denby,
Collected Poems (1975).

Distributed in the United States
and Canada by
Simon & Schuster, Inc.
1230 Avenue of the Americas
New York, New York 10020
simonandschuster.com

Distributed outside the
United States and Canada by
Thames & Hudson, Ltd.
181A High Holborn
London WC1V 7QX
thamesandhudson.com

ISBN 978-1-64423-137-1

Library of Congress
Control Number: 2024936999

Printed in Italy

Our thanks are due to Robert
Cornfield and Mindy Aloff for
their support and collaboration.
Cal Revely-Calder also wishes to
thank Lucie Elven, Hunter Dukes,
Ron Padgett, and Jack Parlett.